Bear Basics
& Beyond

An inspirational guide.
The teddy bear making basics,
through to creating and promoting
your own unique collection.

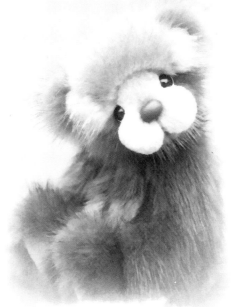

Helen Gleeson

Outskirts Press, Inc.
Denver, Colorado

Bear Basics & Beyond
An inspirational guide. The teddy bear making basics, through to creating and promoting your own unique collection
All Rights Reserved.
Copyright © 2011 Helen Gleeson
V2.0

Outskirts Press, Inc.
http://www.outskirtspress.com

PB ISBN: 978-1-4327-6822-5
HB ISBN: 978-1-4327-6835-5

Outskirts Press and the "OP" logo are trademarks belonging to Outskirts Press, Inc.

PRINTED IN THE UNITED STATES OF AMERICA

Dedication

This book has been written for every fellow bear maker. It's the book I always wanted to buy but could never find on the bookshelves. It should be used as a guide, so study it and enjoy it. Most of all, wherever you are on your bear making journey, be inspired to take one more step, whatever that step is for you. Maybe it's learning how to make a bear or a bear collection for sale. Work toward your dreams and make them beautiful. Remember, every time you make a bear you, in turn, bring a smile to someone, making the world a brighter, better place.

Acknowledgement

Without the constant support of my husband, Ray, neither this book nor my bear art would be possible. My bears are my dreams and they all exist in reality because Ray is always thinking of what he can do and doing it, freeing up my time to spend curled up in my chair sewing, working on my Mac book, blogging and chatting with collectors. He is my rock and my inspiration.

Table of Contents

Step By Step

And Beyond

Introduction

I know most bear books start with the Teddy Roosevelt story and how Margaret Stieff went on to create the "teddy" bear described in the story. I would like to start this book by sharing a story with you, I like to call "The power of the teddy bear. While a bear can be seen as an insignificant stuffed toy often relocated to the attic to be forgotten, there will always be enlightened people who can truly appreciate the power of the teddy bear and the perfection of its soft hug.

My Father has many inspiring tales, gathered over years of serving as a dedicated chaplain with the Fire and Emergency Services of Australia (FESA). He relayed this story to me, my brothers and sister many years ago, when I myself was a teen. I am not sure why the story has resonated with me ever since. It could be because it related to another teen or just the fact that a simple teddy bear could contain such power. Needless to say, being the chaplain for FESA is not a glamorous role. It involves attending callouts in the middle of the night to witness events we pray never touch us, or our families.

The Chaplain at the time was Darryl, and he was called out to an accident. He decided to go along to the hospital where they had transported a young teenager for treatment. Darryl parked his car and was heading for the entrance when he was struck with a thought. Darryl had in his car what are affectionately referred to as tumour teddies. Tumour teddies are a plush manufactured bear, the kind you would find in a large department store, only with a difference. Darryl's wife, Maureen, would make them fireman outfits. Thus, they also had a small helmet atop their heads with a badge proudly displayed.

Darryl retrieved one of the bears from his car and headed for the young girl's room. He stopped in the hallway to talk to her doctor, and the prognosis did not sound good. The doctor explained as best he could that he did not know what to do for the girl. "Physically," he said "she will be ok, but there's something else. It's like she's not really here; she won't talk. We just can't seem to get any response from her." Daryl left the doctor, and walked into the room, not really knowing what to expect. He walked toward the bed, still holding the bear. The girl almost instinctively raised her arms up off the bed, looked at the bear, and longingly whispered "Is that for me?" She hugged that bear with all the strength she had. "Can I keep him?" she asked.

In spite of all the training, knowledge and medical experience a doctor can bring to such situation, a teddy bear can make the connection in a few seconds. It can't quite be explained. The ability to hold onto the bear brings a sense of reassurance to anyone of any age. This is the power of a teddy bear.

I love to show a newly created bear to my family and friends and watch their faces. Even someone who does not fully appreciate the artist's bear and the hours of work will look and smile. It's a wonderful thing to know my bears bring smiles to people daily all over the world. That's the power of a teddy bear.

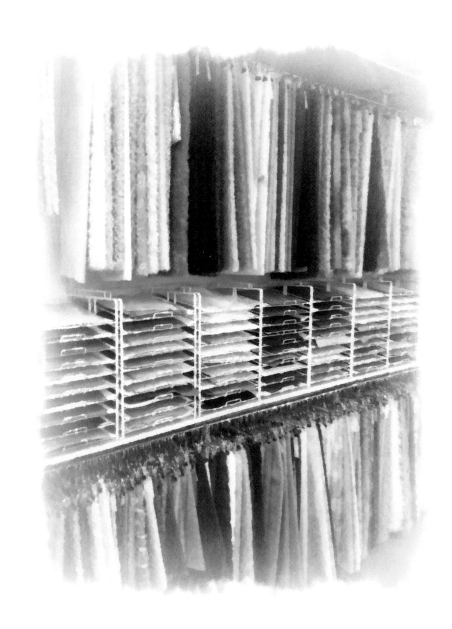

Gather Supplies

There are a few basic supplies you will need to gather to create your bears.

Fur ~ Synthetic

Many bears are created from a range of plush furs. These furs can be synthetic and can range widely in quality. Most new bear makers will work with this at least once. Synthetic fur is readily available in most craft and fabric department stores. These furs can be quite appealing, especially the cost, starting from as little as $10 a fat quarter. A fat quarter is a 18 by 22 inch piece. This is enough to make a reasonably sized 14-inch bear or two to three smaller 7-inch ones. While this may be attractive to a newcomer to the craft, most synthetics are on knit backing. Looking at the weave on the backing fabric you will see that there is a stretch to the fabric, as with any knit fabric. There are, however, many high quality synthetics with woven backings known as faux furs. These can be very dense or have a pile to resemble real fur such as mink and other pelts. Some even contain long guard hairs. Many wedding boleros are created from these furs and this is reflected in the price, generally reserved for mohair and alpaca.

Fur ~ Mohair

Arguably the bear artist's favourite fur comes from the Angora goat. Not related to the Angora rabbit, its name comes from the Arabian word Muhayyar, that is, fabric of the goat hair. Mohair comes in all forms. Swirled, distressed, antique, straight or curly. It is available in short, medium and long pile, this being spare or dense. It also ranges from natural shades to bright, beautiful bold colours. Most furs are available in white you can then dye yourself to the perfect shade. Mohair furs range greatly in cost from as little $30 to well over $100 for a fat quarter.

Fur ~ Alpaca

One of the softest natural fibres originates from alpacas and llamas. Alpaca can be 100% to 25% mohair blends. This fur can look like cotton candy, dense and fluffy. It's great for scissor-sculpting chubby cheeks. Because of the density, alpaca can also be more costly.

Suede, Leather & Cashmere

Suede is one of the most popular paw pad materials and is loved by many artists. It sits smoothly over stuffing. Suede can be used to create layered pads by cutting holes out of the top layer, thus allowing the lower colour to show through. Or if you prefer the more realistic look, you can use your mohair or alpaca for the legs as the paw pad fabric and then appliqué suede paw pads on top. Leather can also be used for the pads. Cashmere is a softer look and may be worth considering if you plan to make soft alpaca female bears in peaches and pinks. This may work with the softer style you are trying to achieve. Do not underestimate the use of good paw pad fabrics and how they blend with your bear's overall look.

Fur ~ Mini Bear Fabrics

Miniature bears can be created from many types of fabrics, such as leather, suede, cashmere or paw pad fabric. Specialty long pile fabric (3-6mm) furs are now available from Sassy furs. Maiden Mills no longer manufactures their long pile upholstery fabrics. However they are still available in limited quantities. Often available in a rainbow of shades, mini bear fabrics can range from $5 to $30 for a 9 by 9 inch square, enough to make one or two small bears.

Fur ~ Real fur

A unique look comes from creating cubs from recycling reclaimed vintage garments. Mink, rabbit, fox and beaver are popular. Mink is the most common but not the cheapest fur with which to work. Mink may be more expensive than fur such as rabbit but I believe it is evident in the finished bear, particularly the face. Mink is available in many colours, the most popular being autumn haze which is a warm honey colour. Dark chocolate, brown, black, mahogany, cream, white and silver are also available. Cream can range from pearl, to beige, to pure white. Many silver shades are referred to as blue iris, and even amethyst. Cross mink is often white with either brown or black tips. Dyed furs in colours such as pinks and blues are rare and again reflected in the price. When working with this fur, the face must be trimmed to perfection. When trimming away the top layers of mink a soft dense straight underfur is visible. Special consideration must be given when working with this medium.

Joints

Artist bears are usually 5-way disc jointed. Arms, legs and neck are standard. Advanced designs, may also include knees or elbows and even double-jointed necks, formed with a wedge shaped addition, connecting the head to the body to allow for many poses such as looking upwards. The most popular joints are either cotter pins or nuts and bolts.

Joints ~ Cotter pins

The pins can have a flat "T" shaped top or a rounded loop. The pin is usually about an inch long. They are also available for miniature bears at half an inch. The cotter pins with the standard loop end can be interlinked to create a wobble joint. This is often used in the neck, allowing the head to flop or tilt slightly, creating a softer look.

Joints ~ Nuts and Bolts

Nuts and bolts are found in larger, more traditional bears. Bolts are available in a range of sizes but commonly also an inch or so long. The nuts for the arms and legs have a lock-tight lining so they will not undo. The neck bolt is standard and held in place with a drop of carefully placed super glue.

Discs

Fibre board, hard board, wooden or metal discs are readily available from 6mm to 60mm.

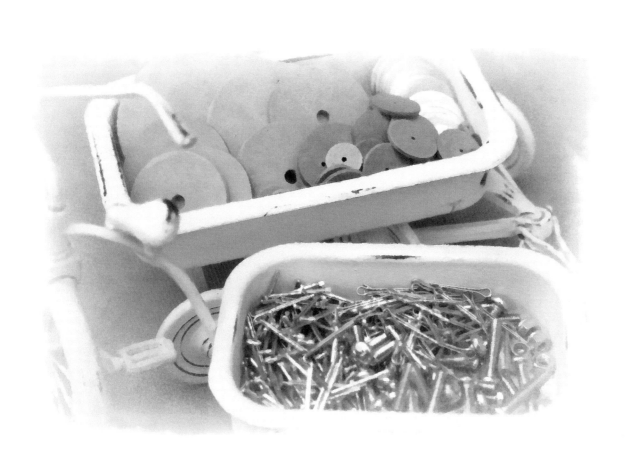

Eyes

Eyes are also known as the gateway to the soul. Glass eyes come on a wire loop, long straight wire to bend down yourself or on a narrow shank which many artists love. High quality individually hand blown dome eyes need to be paired to match both the size and the shape of the dome. If this is not checked, your bear may look like the eyes are not even. Believe it or not, this makes a huge difference in your finished bear's look. Eyes are available in standard black glass. When making antique bears, you can remove some of the shine with sand paper or you can purchase matt eyes. Many suppliers also offer boot button eyes, genuine or reproduced. Standard glass eyes are available in many colours, including clear, brown, amber, blue, charcoal, green, amethyst, topaz and olive, to name just a few. These eyes can change colour when applied to a bear with white suede backing or onto a dark shaded fur. If you apply blue to the eyes of a dark shaded bear they may not appear blue. In this case you can apply a white suede accent as on Neapolitan. Alternatively, if the brown eyes you apply look a bit brighter than you expected, just shade behind the eye with a dark bark copic marker. Specialty eyes such as buzzard eyes create a unique look, these eyes have a black pupil surrounded with a starburst of colour. Buzzard eyes can be costly but are in my opinion worth every cent. If you are after a particular colour, use nail polish and glitter on the back of clear eyes to make the perfect shade.

Black eyes showing the narrow loop backs and standard wires

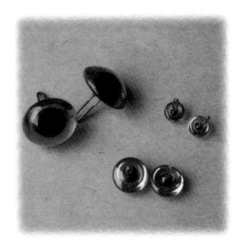

Blue coloured eyes- 14mm, 8mm and 5mm.

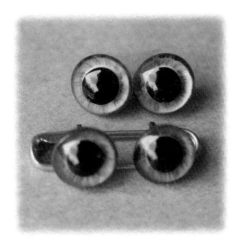

Specialty buzzard eyes in brown, blue and green.

Once you have paired your eyes, you can keep them together on a safety pin.

Threads

Decorative threads create beautiful noses. A solid rich brown or a rainbow of colour from a single strand of variegated thread can create a unique look, or even be your signature style. Pearle threads are great to work with and come in wonderful colours. Pearle balls are available in no 5, 8 and 12 thickness. DMC skeins are available in every colour you can imagine. Take your fur and feet pads along to the store to pick the perfect colour match. Silk threads are beautiful but they are not as easy to work with and may not create a smooth result. A strong sewing thread is best for a strong backstitch; but an upholstery thread or bonded nylon can be used. When working with miniatures you are wise to swap this for an invisible nylon thread, this can take some getting used to, as the nylon will stretch a little. Gutterman also makes 100% polyester threads in many shades. Always match your cotton to the backing fabric not the fur.

Sinew

A waxed thread is used for attaching eyes. It is available from equestrian stores, as used in stitching horse saddles. The threads can be divided onto 3 or 4 individual stands and will grab the stuffing and hold it in place. This thread is super strong and will not break. Sinew can also be used for needle sculpting.

Stuffing

For the many types of bears there are many types of stuffing. Most bears made today are filled with poly-fill or wool, and a little love. Older traditional bears were often filled with wood shavings, straw or foam. Some artists will replicate this when making vintage style bears, ripping holes in the pads so wood or coconut fibres are visible. I like to use Majestic Merino wool noil and poly-fill blend. This has the movement of poly-fill without all the "air" so it tends to stay where you put it. While pure wool can tend to clump, the blend will not.

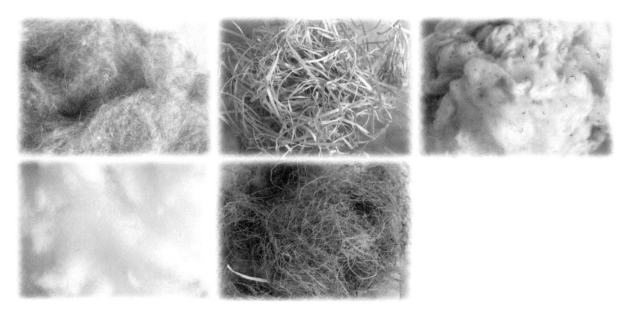

Top left to right: Wool/Poly blend, Wood shavings, Wool.
Bottom left to right: Polyfil, Coconut fibre.

Weight

Steel shot, glass beads and plastic pellets are all used for their varying weights. Steel is the heaviest, so you only need a small amount to weight a bear. This is great for small bears that are very light. Glass will take more of the cavity space, and plastic pellets lighter again, though they can make a bear have a squishy feel. Garnet sand can be added to feet to assist your bear to stand or allow legs to dangle off the side of a shelf in a sitting position.

Clay

Oven cured clay is a versatile medium. It can be used to create a complete face that can be sewn into place or to create just a simple nose. I create my clay noses with a wire shank like that found on the back of an eye. Refer to the clay nose guide to make your own noses.

Wire & Armatures

Armatures, also known as 'bendy limbs' are wire, covered in cloth or foam and have a loop at one end that can be added onto the cotter pin or bolted into the arms and legs. These can be purchased or made. To make your own bendy limbs, see the armature guide.

Acquire Tools

As the saying goes "An artist is as good as his or her tools." I believe this to be true when it comes to bear making. My favourite tool is a simple curved set of 5.5 inch forceps. These are ideal for filling the cheeks with the wool blend, and equally as good when it comes to turning through limbs. Try different tools and you will find your favourite. Keep them together so you have everything you need close at hand. This leather tray with drawer allows me to sew on my chair while not losing a thing, all tucked away in the drawers. It also has a flat little top to work on. These are available at stationary stores.

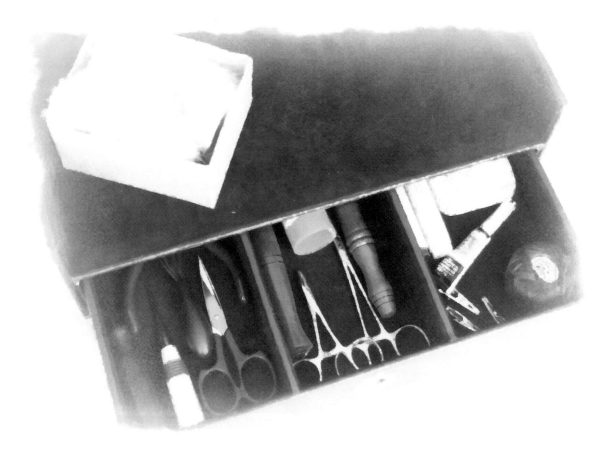

Scissors

The secret to a good cut is good sharp scissors. Scissors do not have to be expensive. I use $5 craft scissors. When trimming faces, particularly when scissor-sculpting mink, use the sharpest scissors you can find. I then retire my scissors to being sharpened once or twice to get some more use from them. I'll use them for cutting up paw pads and fabric, and, finally, for cutting patterns from card.

Forceps

My favourite tool, forceps, are available in many sizes, from 3 to 15 inches to suit most bear makers' requirements. These can be straight or curved. I love to work with curved forceps when filling the cheeks with stuffing as the curve allows you to slide the wool into place up along the fabric, filling the cheeks out as you go. The curve really assists and the forceps do not seem to "poke" the fabric the same way the straight ones do. Forceps can also be used to turn pieces through and are especially wonderful when working with miniatures, as they can reach where our fingers can't.

Pliers

Pliers can be used to turn down cotter pins and cut wire for making noses and armatures.

Stuffing Sticks

Stuffing sticks can be used in conjunction with curved forceps. This is especially helpful when working with miniature bears. If you need to, you can use a knitting needle when making larger bears.

Awl

An awl is a very handy tool. Some awls are quite sharp, like a pin, on top. I like a pointed but smooth, rounded end. An awl is helpful when cleaning your seams, pulling trapped fur out, and also to create a hole for your bolts or cotter pins without cutting any of the fabric weaves.

Brushes

Brushes can be bought from specialty bear fur suppliers for mohair or you can look in your local grocery store in the pet aisle. Another great tool is a brush comb, found at your local chemist's. Brush combs are designed to clean the trapped fur out from your brushes but can be wonderful when wanting to work on a small area like untucking caught fur from the gusset seams and around the eyes.

Cotter Pin Turners

Cotter pin turners come in 2 sizes: standard and mini. These are solid metal tools with a slit in the top. The cotter pin turner slides over one of the cotter pins and allows you to gently roll down the pin into a snail-like roll. The mini turner is thinner and will grip onto the finer pins.

Screwdriver & Socket set

Same as the normal hardware, I am sure many husbands of bear makers are missing their 6.5 sockets. The screwdriver will be used on the bolt inside of the limbs and the socket will slide over the nut inside the body cavity. See jointing guide.

Needles

Many needles are required when making bears, try them all and see what feels best for you. Use the thinnest needle you feel comfortable with. If you wish to work with real fur then a leather needle may assist when working with heavy leather for paw pads. Usually, if you are working with a soft mink pelt, a sharp needle will be fine. Doll needles are also required when inserting eyes or stitching noses and mouths. Try to have a range of doll needles, as you do not want to be working with a 10-inch needle when working on a head that may only be one inch in diameter. Nor do you want to struggle with a small 3- or 4-inch needle if the head itself is that size.

Pins & Clips

I rarely use pins but they are a good idea to have at either end of a limb to ensure that you have the pieces in the right place. When working with pelts do not use pins, as you do not want extra holes in the leather. Use small alligator or electrical clips. Appliqué pins are wonderfully small, making them great to work with. Always use a pin cushion either on your wrist or like the ring above. Do not put pins and needles into your armchair, or worse, lose them around the house.

Copic markers & Pencils

Copic markers are available in many shades and come with a broad and narrow tip on either end. The markers can be used in conjunction with bender pens. A bender pen is a clear pen that is used to blend or evenly distribute the colour. Airbrush packs are also available, turning the standard pen into an airbrush system, thus allowing for a soft spray of colour. Invest in a dark bark copic, it's a deep brown and not harsh like black can be. You may be surprised but you can shade around the eyes and nose of a bear of just about any colour, giving a soft depth to the features.

Collect Fur

The most simple of action points to take away from this book: Always be collecting. Many furs are limited editions or brought into the county on a fabric roll and may not be re-ordered. If you see a fur you just have to have, buy it. You will be so disappointed when an idea comes to you and you imagine the perfect fur only to find out you cannot purchase it anymore, or it was hand–dyed and cannot be reproduced because you can't quite explain the shade of soft coral it was. If you want a piece of every fur you see, a good option is to by a 1/16 or 1/8 and try them all. In this way, you can settle on your favourite style. Real fur such as mink can be found at vintage or antique stores. I am often asked where to buy this fur; you can also try second hand stores and even online. However, here is my warning. First of all, not everyone understands the classification of mink. I see people, maybe innocently enough, list fur coats as mink coats. Now here is a difference, not all fur coats are mink. When you are buying fur online, the fur can look fine, however when you receive it and remove the lining you may be disappointed to realize the leather is not soft but dry and will tear with little effort. If this is the case you can't use the fur, as turning the limbs would be enough to rip a hole. If you are making a panda style bear in two tones, you will need two coats, so you may find, what seems to be an expensive kit is well worth the investment.

Stitches

Backstitch

The simple backstitch is the bear marker's best friend. It is a very simple stitch and you can hand stitch any size bear with this same backstitch. You want your backstitch to be firm and taut, not puckered or loose.

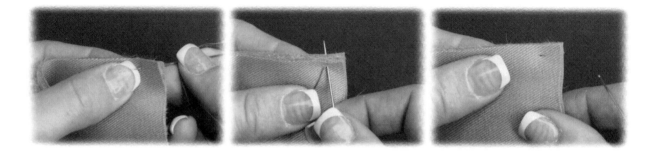

Knot the end of your thread. Holding your fabric, bring your threaded needle up through the fabric toward you. Then back down right next to where you came up. This is just an anchor stitch.

The backstitch moves along the back of your fabric. Move forward a stitch length (This varies from pattern to pattern) and insert the needle through the fabric toward you again.

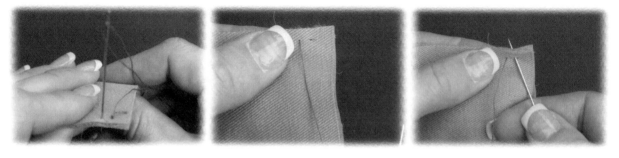

Now create the backwards motion inserting the needle into the first stitch already visible.

Move along the back of the fabric again, and insert the needle through the fabric toward you, and back into the previous stitch. Repeat. You can see three backstitches formed here. Make sure your thread passes through your fabric straight, as an angle will warp your pattern piece.

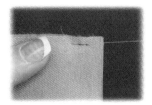

Ladder Stitch

The ladder stitch is used for closing openings and attaching ears. The name comes from the shape, each rung of the ladder lies directly across the opening. The rungs must be straight to ensure the opening closes as smoothly as the rest of your seams. You don't want to be able to feel the lumps and bumps created from a ladder stitch where the rungs are on angles.

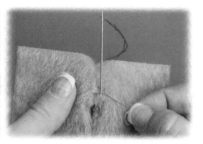

Thread a needle and knot the end. When ladder stitching an opening closed, bring the needle up through the top left hand corner of the opening, catching the knot behind the fur. Bring the needle up through the fur toward you. Take the thread directly across the opening, and it must be straight. Insert the needle into the fur, picking up about 3 mm and come out again on top of the fur just a little below the first stitch. Now you're ready for another stitch straight across the opening.

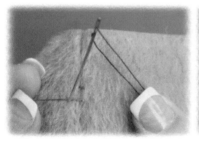
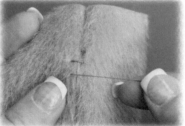

Think of a ladder, all the rungs are on top of the opening left to right, right to left. The sides of the ladder are on the underside of the fur. When you get to the bottom of the opening, tighten the thread, watching the opening close up and knot off.

Jointing

Wobble Joint – Double Cotter pin

A wobble joint is created using two cotter pins interlinked. These are often used in the head to give your bear a soft tilt or flop to the head.

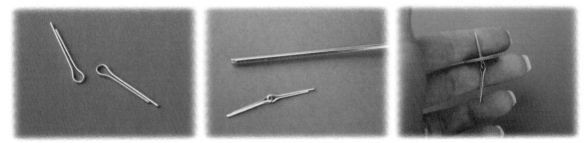

When creating a wobble joint for the neck, interlink two pins, and thread a disc onto one of the pins. Using a cotter pin turner, slip it onto the longer of the two pins and gently roll it down to form a snail like roll. Repeat for the shorter pin in the opposite direction.

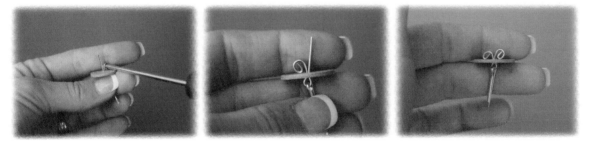

The last picture shows what the cotter pin would look like. Insert the disc into the head, opening and gathering your thread around the joint thus closing the head opening. The other pin is then inserted into the top of the body and another disc added into the body before rolling this cotter pin down in the same manner as before.

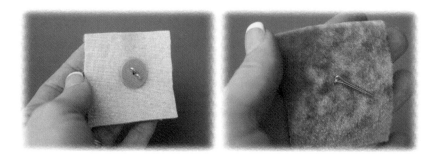

If you choose to wobble-joint the whole bear (keep in mind it will not sit up very well) you can interlock your pins and insert one end into the limb and the other into the body, adding the disc to each, then rolling down the pins.

When using a T pin the T is threaded through the disc, into the limb and then the body. Another disc is added; then the pins are rolled down just as in the double cotter pin above.

Nut & Blot Joint

Create a hole in the fabric weave with your awl (this would represent the limb)

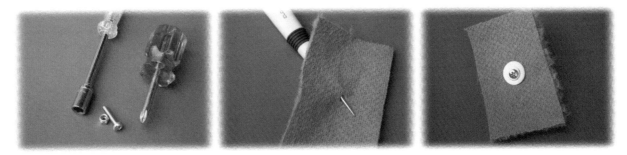

Insert the bolt with the appropriate sized disc and washer in the shown order.

Insert the bolt into the body from the outside, reach into the body cavity to thread on the other disc, then the washer, then the nut.

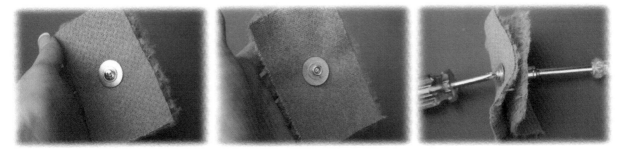

Using a small screwdriver for the bolt (in the limb) and a socket on the nut (in the body) twist in the opposite directions. To ensure all the limbs are tightened evenly, I like to tighten them all up and then loosen each off half a turn, checking again they are all even.

Slit Jointing

The slit method is a wonderful way to joint, suitable for smaller bears that you intend to create using cotter pins. This is not suitable for bears with nuts and bolts, as you need both the limb and the back body open to tighten with a socket and screwdriver set, whereas with a cotter pin turner you only need access to the inside of the body. In this method you complete the limbs, then attach to the body without the need to ladder stitch all the openings closed at the end.

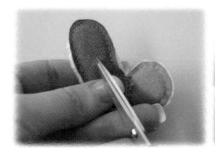 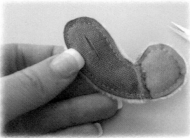 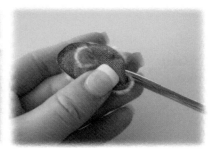

First, sew your limb, leaving no opening at all. Sew all the way around the limb. The opening is then slit into the centre of the limb where the joint will go (the same applies to the leg). Slit the limb and turn it through. If you are struggling to turn it, just extend the slit a little.

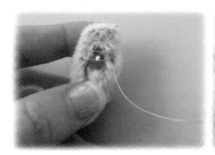 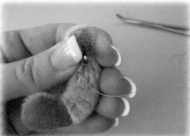 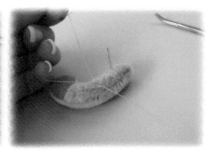

Airbrush & Shading

Now airbrushing might sound like a difficult skill to master, with a lot of expensive equipment required. Yes, you can buy an air compressor and brush set, but you can start off with a simple, inexpensive copic set. The whole set up including pens will cost you less than $100. You simply slide the pen into place and there is a little button on top which you press, which will release air from the can, pushing the air past the pen nib, taking colour with the air. The air cans can be replaced and screwed into the bottom of the holder as needed. Changing colour is simple and there is no cleaning

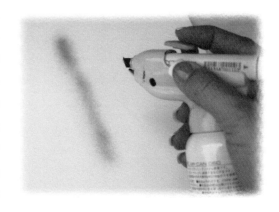

up paints. Just put the lid back on. The nibs can be replaced and the pens can be refilled. I refill my dark bark and blender pens, keeping extra nibs for when they are needed. Practise on card and keep your scraps of fur to check the result before spraying directly onto your bear. You can see by spraying on card how far the pen needs to be away from your bear for the result you are after. The closer the pen, the heavier and smaller the diameter of the spray. Airbrushing can be as simple as a light shading behind the eyes to add depth or as extensive as creating a white bear and shading an all over pattern. Experiment with shading, using pencils and blenders.

Clay Nose

There are many types of clay available today from specialty craft, school supply, newsagents and large department stores. The clays are available in a range of colours from primary, to pastel, to glitter and even pearl lustre. You can mix two colours together for the perfect blended shade, or paint the desired colour once finished. The clay should not dry out, but keep it together in a tin when not in use.

The following instructions are suitable for Sculpy and Fimo. Make sure you read the directions on the clay you purchase. Again, read all the instructions before you begin. I also suggest you have your bear's face complete, that the nose area is firm with no puckers, and you trim away the fur from where the nose will sit.

Step 1

Cut a piece of clay off the block. As a guide a 4" miniature bear will take about a 6mm ball, a 8" bear will need about 10mm ball and so on. You need to make the proportions of your design flattering to your bear. You do not want him to look like he has a big blob on his head. Roll the clay into a rough ball.

Step 2

Look at the ball and compare the size to your bear's face, Cut through the clay at the centre of the ball; if you feel it is too big cut more than 1/2 off the back. The clay should now resemble a nose for your bear.

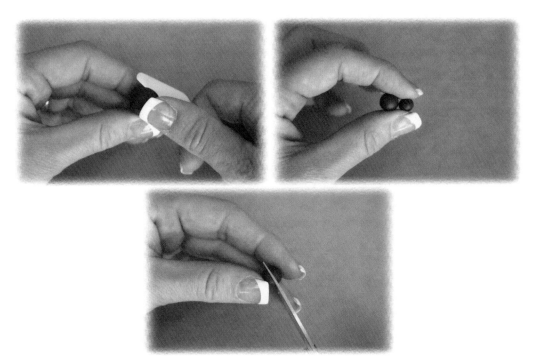

Step 3

Place the clay on your index finger. Using your other index finger and thumb, GENTLY shape the top and bottom of the nose, then side to side. Gently shape the dome of the nose to a smooth finish.

Step 4

Place the nose in front of your bear's face to see if you're happy with it. If you are not, either continue to shape or roll into a ball and start again! When you are happy, set aside. At this point you can skip step 5 and go straight to step 6 and superglue it onto your bear. However I now go to step 5.

Step 5

Using a thin gauge wire, simple doorbell wire, florist wire, or beading wire and a set of small haemostats, make a little U-shaped loop. Using wire cutters, snip the wire. Holding the nose, dome side down in the palm of your hand, pick up the "U" shaped loop in the haemostats and very lightly push into the centre of the clay, being careful not to change the shape. Holding the nose by the loop with the haemostats, check again until you are happy with the shape. This is the last chance to perfect the shape.

Step 6

Check the directions on the packet. Sculpy and Fimo requires being heat set. A nose this size only takes a few minutes. Takes up to 10 for a larger nose to suit a 20" bear. You can use an oven or frypan. I use a small toaster oven outside, as they can give off fumes. If using a frypan, or baking tray put some foil down first: you don't want your nose to stick. Preheat the oven at about 80-100 degrees. Put the nose, Haemostats and all, into the oven till hot. When you touch the clay you should be able to feel the heat inside. Be careful not to burn yourself and do not touch the metal haemostats. Once you are satisfied that the nose has been heated, you can turn off the oven and allow to cool. Once the nose is cold it should be hard.

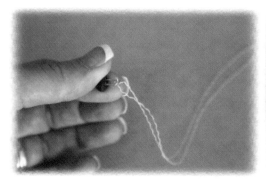 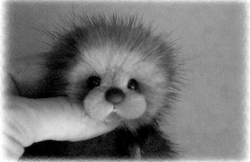

Step 7

Remove the metal loop from the back, as the clay is not designed to stick to metal. Add a tiny drop of superglue to the holes. Be careful not to get glue on the front or sides of the clay nose. Insert the wire loop back into the holes. Your nose is now finished. To attach to your bear, follow the same steps as for eyes. Loop sinew through the wire loop. Thread one stand, then the other, through the bear's face, holding the nose and applying pressure. Do not put pressure on the wire and tie off. Use the button method and tie off inside the head, before closing.

Appliqué Paw Pads

Paw pads can be simple or they can be the wow factor in your bear. Creating these pads can bring all the colours in your bear together. The paw pad is cut from the same fabric as the leg, then trimmed back. You can also pluck or shave the areas you wish to cover. Cut the raised pads from suede. Appliqué these pieces onto the original fur paw pad using a small backstitch 1 or 2mm from the edge. To raise them up, cut slits in the paw pads at the back and gently fill with stuffing. Then ladder stitch the slits closed. If you wish you can shade the raised pads so they blend into the foot. I have also used Pearle cotton to turn the top one pad into 4 toes.

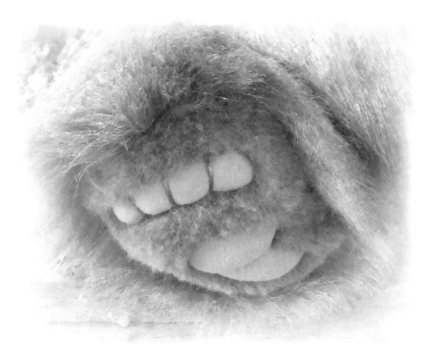

Armatures

Armatures or bendy limbs are available commercially or can be made to measure. This armature has been made from a hair curler and the wire has been exposed at one end to clip on an electrical terminator, available at all hardware stores. This is an easy way to make armatures as you can make them in many sizes from a selection of curlers and terminators. These bendy limbs will end up costing you less than a dollar each to make. You can have bags ready to make cutting the wire length to suit, adding the cap back on to protect your bear from protruding wire. As shown, this simply slips onto the bolt before jointing. When stuffing the limbs, ensure that you work your stuffing all the way around the armature, keeping it centred. This will give your bear realism and ensure arms are not pointing awkwardly outwards.

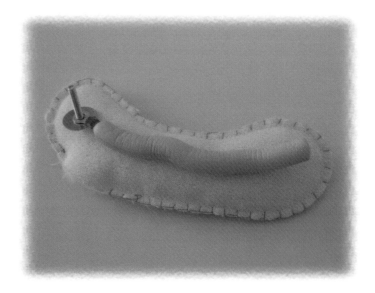

Create your own Accessories

Cupcakes

Cupcakes can be made from Pottery Plater using silicon moulds. Once dry and hardened they can be painted and embellished with beautiful sprinkles. Cupcakes can be made to match clothes or fur.

Antique blocks

I have created blocks with an initial to suit a bear's name and also "Bare Cub Designs" blocks to display with my bears at shows. This has a double use. Not only do they look great on your table, they promote your business name. Of course these can be made in many colour combinations.

Pendants

Create inexpensive pendants from wooden beads available at jewellery supply stores. Similar to the wooden blocks, use your favourite scrapbooking papers and Mod podge paint the beads and decoupage. Finish with a Mod podge topcoat and thread onto some string to hang around your bear's neck.

Toadstools

Make stems and caps from cream clay. Airbrush the caps with a dark bark copic marker or paint red with cream dots for fairy bears. Attach the caps to the stems with toothpicks and super glue.

Knitting hats

Knitting clothes for bears is another good way to incorporate colour into your work. Hats are a very simple pattern to work with. Knit and purl are the only required stitches needed. I like to knit in miniature using DMC thread and small needles. I also adorn hats with beads and collect tiny buttons for the overalls.

Overalls

Cotton overalls can be sewn up in minutes and the pattern is easily adapted to many bear sizes.

Pattern One

Neapolitan

To make this bear you will need the following supplies, but remember you can use the fur that you love and colours you prefer to work in.

You will need:

- Straight pile 1 inch Alpaca (fat quarter)
- Suede
- Eyes 12mm charcoal or Blue
- Joints nuts and bolts with 30mm discs
- Stuffing: I like to use a poly wool blend
- Steel shot optional
- Cotton for nose and mouth
- Matching sewing thread; I like to use upholstery thread
- White ultra suede scrap for eye accents
- Sewing needle and Doll needles (see tool guide)
- Haemostats (I like to use curved)
- Sharp Scissors, Awl, Pen,
- Screwdriver and socket set
- Finished bear: 14 inches

Preparation:

Read through the instructions before you begin. Print the pattern on card and cut out. There should be 21 pieces. Place the fabric, fur side down onto your work area, making sure the pile runs down toward you. Place the pattern pieces onto the back of the fabric so that the arrows are facing the same direction as the fur pile. Confirm that you have all the pieces; there should be 15 pieces in total (remember 2 paws, 2 feet and 2 ears are in suede). Cut out all the pieces carefully as not to cut the fur pile. Trace the paw pads and ears onto the suede or fabric, all facing the same direction. Cut out. A 3~5mm seam allowance has been included in the pattern.

Body:

Sew all four darts on the body first. Placing the two body pieces together and using a firm small backstitch, sew around the tummy, leaving the opening. Using the awl, pull the trapped fur out of the seams. Turn right side out.

Arms:

Sew the paw pads onto the bottom of the inner arms. Place the inner and outer arm together and sew around, leaving the opening. Pull the trapped fur out of the seams. Turn right side out. Using the haemostats or stuffing stick, gently fill the bottom half of arms (up to the openings). Repeat for other arm.

Legs:

Place the two leg right sides together, sew from the heel to the bottom of the opening, leaving an opening. Then continue sewing from the top of opening around to the toe. Clean trapped fur from seams. Repeat for other leg.

Paw Pads:

Start at the toe and sew the foot pad into the bottom of the leg. Make sure the heel lines up with the back seam, working on one side and then the other as you complete the pad.

Head:

Place the two head pieces, right sides together. Sew from the nose down the chin to the neck opening. Place the gusset (rounded end) where the nose pieces meet, making sure you start in the middle of the gusset. Sew the left side first, adjusting as you go to make sure the end of the gusset meets the neck opening. Starting back at the middle of the head gusset, work around to the right ending at the neck. Leave the neck open. Clean trapped fur from seams. Turn head right sides out. Using the haemostats or a stuffing tool, gently stuff the head, making sure that you pay particular attention to making the nose area firm, as this will help when you are sewing the nose. Insert a bolt and disk into the bottom of the neck opening, with the bolt coming out the bottom of the head. With sinew thread, gather the neck hole around the bolt and knot the end off. Sink the knot into the head.

Eyes with accents:

Using pins or test eyes and the photo as a guide, decide where you want to put the eyes. Make sure they are even. Thread the eyes onto sinew. Thread the other end of the sinew through the eye of a doll needle. Cut two round circles from the white ultra suede. Place a small hole in the centre of the circle with the awl. Thread onto needle so that the white is up against the bottom of the eye. Insert the needle where the eye will go and exit at the back of the head near the neck. Bring both threads out close together and tie a reef knot, sink knot back into the head. If you wish to you can sculpt the head while inserting the eyes. This is done by using the sinew across the bear's head usually from the ear area to the eye area to create eye sockets. I also like to use a button method for inserting eyes, it works like a pulley system allowing you to sink the button into the head opening and then tightening the eyes. You can do this on your own; you do not need the help of a friend. Then tying the threads off inside the head, you do not end up with a dimple at the back of the head. I also like to sculpt the eyes The complete step by step guide to sculpting and the button method are included in the Bare Cub Designs Club. Details are in the back of this book.

Nose:

Using sharp scissors, trim the fur from the nose area Thread the Pearle cotton onto a doll needle and, entering the back of the head, come out at the centre of the nose, forming the septum. Go back into the head a few mm below, coming out at the bottom left hand of the mouth. Then pull thread through but not tight. Threading the needle underneath the septum to the right hand side, pull the thread tight and enter the head at the bottom right side of the mouth. Exit the head at the back, tie it off and sink knot into the head. Option - Make a nose from polymer clay, following directions on the packet. Attach with strong glue or by attaching a wire loop into the back of the clay (before baking) and attach in the same manner as the eyes. See the Guide to making your own clay nose.

Ears:

Placing right sides together, sew around the curved edge, and remove the fur from the seams. Turn through. Ladder stitch the ear opening closed, leaving the hanging thread attached. Repeat for other ear. Attach the ears to the head using ladder stitch and the hanging thread. Use the photo as a guide or place with pins first to make sure you are pleased with them and that they are even.

Jointing:

Attach the head by inserting the bolt into the neck of the body. From the inside of the tummy, thread a disk onto the bolt and tighten nut. Squirt a drop of superglue on the nut to ensure this remains tight. Insert the bolts into the joints where marked and attach the arms and legs. Tighten until firm. Gently fill the arms and legs with wool. Fill tummy, paying particular attention to the neck and where the joints are. Fill a stocking foot with steel shot, tie off with a knot and put into tummy for weight if you wish. Finish filling with wool. Using ladder stitch, sew up the back opening of the body, arms and legs. Clean all the seams by using an awl to pull out any trapped fur on the outside of the bear.

Recycled Fur

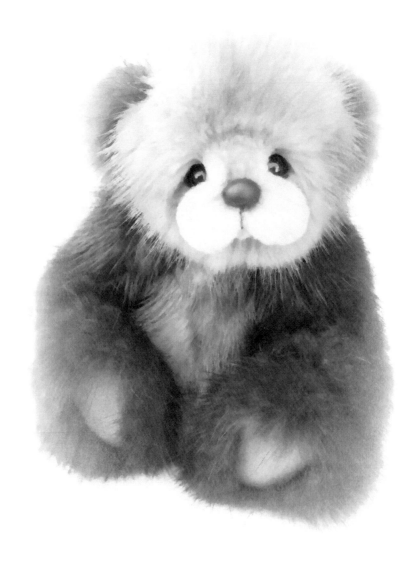

Creating with Recycled Fur

When creating cubs from real fur there are a few things to take into consideration.

Purchasing

You can purchase recycled mink fur from many places. Antique stores are a good option because you can see what you are buying, not relying on photos as when purchasing online. The difficult part is knowing if the pelts are in good condition. If the garment has a French hem you will be able to lift the lining and see the pelts. Some garments will have a soft mesh covering the pelts but this is usually clear. The pelts need to be soft and supple. They will be either full pelts or "let out." This is when the pelt is shredded up and sewn back together; it will look like tiny patchwork arrows. The working area will be anywhere from 2-inch strips to 20-inch blocks. This needs to be taken into account as a 4-inch wide body if placed on the 2-inch strips may have a sliver of leather running down it, and you do not want this.

Preparation

Any recycled fur garments need to have all the lining removed. This usually comes away easily. However, use sharp scissors to cut away the stitches; don't be tempted to pull the lining as you may rip the leather. The leather should be soft and supple, not hard or dry. I like to cut away all the lining and cut the arms away so you know what you are working with. Remove the collar and even the front sides from the back panel. If the lining has been tacked all over, you will need to use forceps to remove these stitches. If you have cut each part of the garment up, you can then store in a neat pile in a basket or a garment bag under a bed. If you do not intend to use the coat for a time you can store in a cool, dry place such as a spare cupboard. Do not store coats on wire hangers as this will put pressure on the seams. Use a large wooden hanger if you need to hang it. Store the bears you are working on in

a small box – never store real fur in plastic bags.

Once the leather is exposed you can begin tracing the pattern onto the leather with a ball point pen. I use the Bostic Blue non-toxic Glue stick. Not sure why but the blue one that dries clear seems to work the best. Make sure the glue goes well over the edge of the piece – you do not want the edges to lift. Using very fine muslin, with a nice tight weave (not calico – it's too thick), place this over the area traced and flatten with your hands. Make sure you have no bumps or lumps. You should be able to see your lines marked. Double check that all the pieces are there and in the right colours. The face and body can be made from a lighter colour than the arms, legs and ears if you want the "panda" look. If you find there are sections that are not clear using the visible lines, retrace the pattern pieces onto the muslin, being careful not to stretch the muslin.

Care

You should keep your fur in a dry cool place. Do so even with a completed bear. Do not store bears on a hot window ledge where the afternoon sun comes in. If the fur coat needs to be cleaned, take it along to a dry cleaner that offers the services for specialty furs. Many dry cleaners will send away for you, so it's worth finding out who they use. Your fur may not look dirty but built up oils can weigh down the fur and it's surprising how beautiful and fluffy your fur can be if cleaned well. It will also help with any musty smells from being stored for long periods.

Trimming the face

To start, we break the face down into sections. It might be hard to believe there is a face under all the fur but, trust me, it is there. Cutting it into sections, we bite off one area at a time. The first section is the gusset. Only worry about the gusset right now, nothing else. Move the fur around with the closed tips of your scissors or an awl. Just try to understand and separate the gusset fur from the side head pieces. Start by just trimming the fur on the gusset. When cutting the fur, think of it as layers. We trim quite low on the gusset but always in layers. Cut the tips on the fur just a few mm, then a few more, and you will get lower and lower. This allows you to trim neatly. If you just cut straight in low you will get what I call "hack marks," leaving obvious cuts in your fur. Next, I trim down the sides of the face from the eyes in a curved motion around to the mouth area. This will define the cheek area. Then I go over this a few times so it is more visible to me. Now I can trim the cheeks, starting with the guard hairs, then forming the shape by watching the angle of my scissors. If you are interested in working with mink and seeing every step, The Bare Designs Club has a mink issue with over 150 photos of how to work with mink and trim the face. For more information visit www.barecubdesigns.com. The mink can also be shaded with copic markers, blending the nose and eyes with the fur for a more natural look. You can see I insert the eyes in a special way using a button in the head like a pulley system. This not only allows me to sculpt eyes, all on my own but I do not have to worry about sinew getting stuck in the mink at the back of the head.

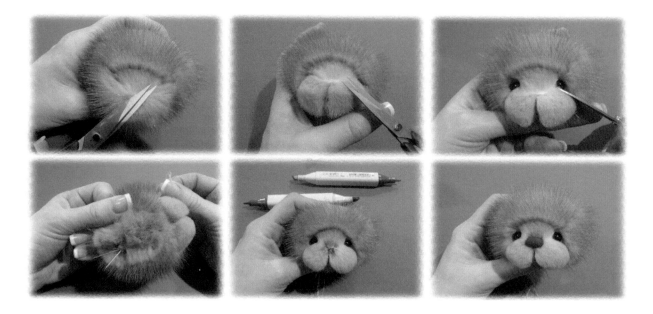

A few of the steps shown. First, trimming the gusset area, then defining the cheeks, trimming in around the eyes while in the test position and then inserting them with the button method. I finish off with a bit of soft shading and a clay nose, avoiding extra holes in the face from a thread nose.

Pattern Two

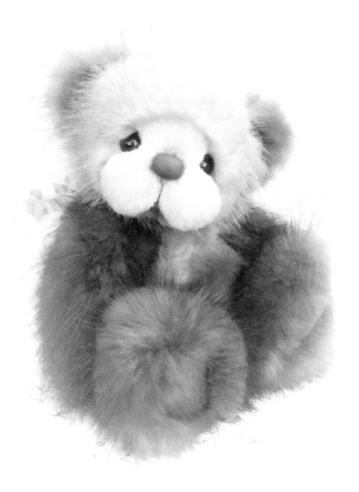

Hershy

This bear can be created from any real fur (or even alpaca if you prefer). You can use two colours to create the panda style or one colour.

You will need:

- Mink Fur in Chocolate and Honey
- Muslin and Blue Glue stick
- Suede
- Eyes: 8mm black glass eyes
- Joints T pins with 15mm discs
- Stuffing (I like to use wool for mink bears)
- Steel shot (optional)
- Cotton for nose and mouth
- Matching thread
- Clay for nose
- Sewing needle and Doll needle
- Haemostats (I like to use curved)
- Sharp Scissors, Awl, Pen, Cotter pin turner
- 7-inch bear

Preparation:

Read through the instructions before you begin. Photocopy this pattern onto card and cut out. If you intend to use the pattern again and again I like to cut it out of template plastic, as this will be durable. There should be 21 pieces. Place the fabric, fur side down, onto your work area, making sure the fur runs down toward you. Place the pattern pieces onto the back of the leather so that the arrows are facing the same direction as the fur pile. Confirm that you have all the pieces; there should be 15 pieces in total (remember 4 paws and 2 ears are in suede). Cut out all the pieces carefully so as not to cut the fur pile. Trace the 4 paw pads, and 2 ears onto the suede, all facing the same direction. Cut out. A 3mm seam allowance has been included in the pattern.

Body:

Sew all four darts on the body first. Placing the two body pieces together, using a firm small backstitch, sew around the tummy, leaving the opening. Using the awl, pull the trapped fur out of the seams. Turn right side out.

Arms:

Sew the paw pads onto the bottom of the inner arms. Place the inner and outer arm together and sew around, leaving the opening. Pull the trapped fur out of the seams. Turn right side out. Using the haemostats or stuffing stick, gently fill the bottom half of arms (up to the openings). Repeat for other arm.

Legs:

Place the two leg right sides together, sewing from the heel to the bottom of the opening, leaving an opening. Then continue sewing from the top of opening around to the toe. Clean trapped fur from seams. Repeat for other leg.

Paw Pads:

Insert the pads for feet. Start at the toe and sew the foot pad into the bottom of the leg. Make sure the heel lines up with the back seam, working on one side and then the other as you complete the pad.

Head:

Place the two head pieces, right sides together. Sew from the nose down the chin to the neck opening. Place the gusset (rounded end) where the nose pieces meet, making sure you start in the middle of the gusset. Sew the left side first, adjusting as you go to make sure the end of the gusset meets the neck opening. Starting back at the middle of the head gusset, work around to the right, ending at the neck. Leave the neck open. Clean trapped fur from seams. Turn head right side out. Using the haemostats or a stuffing tool, gently stuff the head, making sure that you pay particular attention to making the nose area firm, as this will help when you are sewing the nose.

Eyes:

Insert the eyes. I strongly recommend when working with real fur that you use the button method I mentioned earlier. This is very important when working with real fur as the dimple is not as much an issue as the fine fur being caught up in the knot at the back of the head. This also allows you to pull in the eye sockets while not putting any stress on the leather.

Nose:

Using sharp scissors, trim the fur from the nose area. Thread the Pearle cotton onto a doll needle and, entering the back of the head, come out at the centre of the nose forming the septum. Go back into the head a few mm below, coming out at the bottom left hand of the mouth. Pull thread through but not tight. Threading the needle underneath the septum to the right hand side, pull the thread tight and enter the head at the bottom right hand side of the mouth. Exit the head at the neck opening. Make a nose from polymer clay, following directions on the packet. Attach with strong glue or by attaching a wire loop into the back of the clay (before baking) and attach in the same manner as the eyes.

Ears:

Placing right sides together, sew around the curved edge, remove trapped fur from the seams. Turn through. Ladder stitch the ear opening closed, leaving the hanging thread attached. Repeat other ear. Attach the ears to the head using ladder stitch and the hanging thread. Use the photo as a guide or place with pins first to make sure you are happy with them and that they are even.

Jointing:

Attach the head by inserting the cotter pin into the neck of the body. From the inside of the tummy turn the pins down with a cotter pin turner. Continue with the arms and legs in the same way. Fill tummy, paying particular attention to the neck and where the joints are. Fill a stocking foot with steel shot, tie off with a knot and put into tummy for weight (optional). Finish filling with wool. Using ladder stitch, sew up the back opening of the body, arms and legs. Clean all the seams by using an awl to pull out any trapped fur on the outside of the bear.

Finishing/Shading:

Shade around the nose and eyes with copic markers and blender as desired.

AND BEYOND

Sew… What's next? You want to be an Artist?

First, let's understand the term 'bear artist,' often confused with 'bear maker.' What is a novice? A professional? When entering your work into a competition, common categories are used such as: novice, open, professional and master professional. When entering a competition refer to their guidelines, as there are no universal definitions. Novices are usually referred to as bear makers who have only been making bears for less than one year. Open are those who have been involved over one year, and professionals are those who sell their own designs or teach regularly. Master professionals are those who may have previously won the award as professional. Some competitions will bump you up a category if you have won in that category the previous year. In general terms a bear maker or hobbyist is someone who makes bears. Usually they will use commercially available patterns and enjoy making bears for relaxation and often keep the bear. Others may give them as gifts to family and friends. So the term bear maker fits well. A bear artist is someone who has decided that making bears is more than a pastime or hobby, and more of a passion. Artists have a passion for designing and creating their own unique bears. They will often sell their work to collectors. Master professional are those who not only create and design their own work but choose to experiment with advanced techniques like scissor sculpting or extensive needle felting. They have mastered their art and this is reflected in the style of bear they create. Many master professionals offer their own time to promote the world of bear making in some way and will be happy to pass on their knowledge, advice and experiences to others.

So what does it take to be a bear artist? I believe you must be more than someone who can simply design and create beautiful bears. You must be part editor, publisher, promoter, web designer, graphic artist, art director, stylist and accountant, to name just a few. Least important is to be a professional salesperson. I believe the bears will sell themselves. When you're creating a unique top quality collectable bear, you will not have to sell them. You will, rather, have to keep up with the orders that come your way, often selling a bear that does not yet exist.

What comes first. A name? A style? Well, I think these go hand in hand. You need to think about where you have come from—all the bears you have made that bring you to this point. What is your aesthetic style? With this in mind, think of how best to get that point across. Your collection should be focused, your message carefully edited. Then as you expand, your message will be clear. A collector should be able to see your point of view within moments, as that is all they may give you. Do you prefer to work with miniatures making tiny characters with little hand sewn overalls or knitted hats. Or maybe you like to make vintage, inspired large traditional bears with coconut fibres and dark shading and patchy mohair. Maybe your ideal bear is created from reclaimed vintage furs with fluffy cheeks in neutral hues. Maybe you love colour and can't get enough, so you choose to hand-dye furs in multi colours and finish off with your signature style variegated nose.

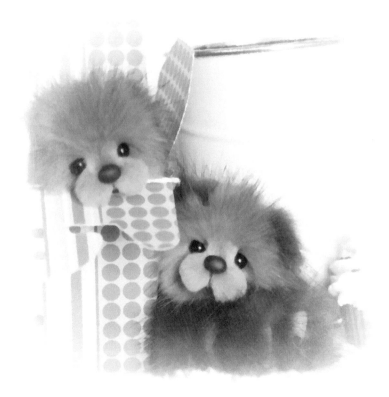

Now I don't mean to say the end result will be there from day one. Your bears are bound to improve over time, but your style is your style. Think about who you are and what your creations will reflect. Keeping this in mind, think about how you want to be remembered, and the point here is you do want to be remembered. It's the old name game. Maybe you want your bears to be named after you, but if your surname is the one the teacher always got wrong at school then, the chances are, so will your collectors. Sometimes a simple name is the best. I am not saying you can't be creative but if people cannot pronounce your name they will tend not to say it and this can be a terrible shame. Word of mouth is very good indeed. Of course once you have the name you need others to know about it.

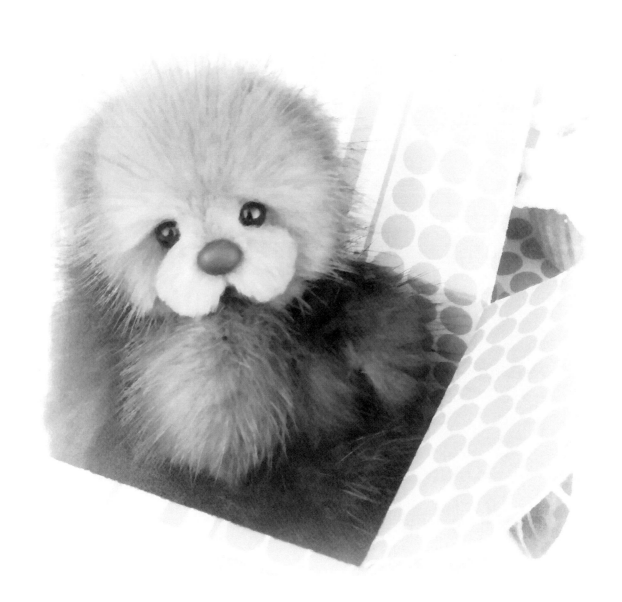

Create the bears you want to buy

Your collection should be appealing to you and you should want to buy them all. You may be inspired by other people's work but remember your work needs to reflect you. Gather photos of colours and furs that you like and carry a notebook with you so when an idea comes to you, jot it down, and draw sketches of bears you wish to make, always thinking of what you like. You don't want to be bored after 6 months of making your collection. You should be creating your own work from your own patterns. I am often asked by bear makers and even other artists about my patterns and if they are copyrighted. Now, many people have various ideas on the law and their interpretation of it and many people choose to grow quite heated over this topic. I believe, regardless of the law, that there is nothing like the feeling of designing, creating and selling your own bear. With that in mind, here is my response when I receive an email saying, they love my bears, have made my patterns, enjoyed my step by step guides wish to be artists, and would like to use my pattern to make their bears. Some makers go on to say that they have tried their own designs and are not happy with the number of sales.

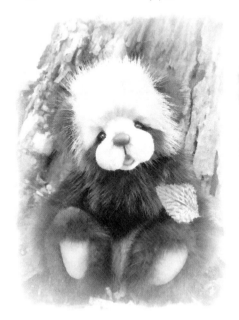
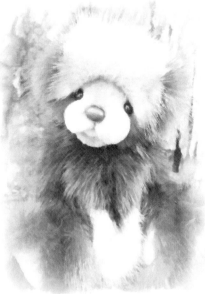

First of all, I thank them for their letter as it is quite an honour that they like my patterns enough to want to use them and are honest enough to ask and not just use them without my consent. I go on to explain the thrill I get each and every time a collector sends me an email saying " I love your latest bear – he is adorable, I love his cheeks and those eyes, I just have to have him for my collection. Your bears make me smile!" There is nothing quite like it. That's the joy for me. I want them to feel that. I tell them no one has ever emailed me and said "I really like the shape and length of the arms on your latest bear. The head is in perfect proportion to the body. Can I adopt him?"

There are exceptions, some designers have immaculate designs and create amazing critters, but I still believe their work sells because of what they do with that pattern. Many bears are just that: bears. A head, two arms, two legs and a body. A good design is important but not more important than an appealing face. I offer to help them make their own pattern or am happy to give a positive critique to the pattern they are already using. If your bears are not selling, you will need to take a hard look at your collection. In most cases the underlying pattern is sound or may only need a tweak here and there. Creating from your own design becomes the foundation of your passion. Be inspired by artists. In reality, no one is after my design; they are after my bear, which they can adopt from me. However, using my pattern will not bring you joy, nor in my opinion make you an artist. My advice remains, ask people for their opinion, but I must warn you, family and friends will say what they think you want to hear. And some simply do not have the collector's eye. You are wiser to ask a fellow bear maker and let them know your desire is for positive criticism; this will give them the right to be honest with you. Be prepared. It might hurt a little hearing it, but just think how much you can improve after hearing this. It's also very valuable to have a mentor with whom you can talk who will be honest and give you positive comments too.

Zhu Zhu and Basil have been designed with over 40 pattern pieces including open mouth, tongue and double jointed neck, with raised appliquéd paw pads. See how different a bear can look though created from the same pattern. A panda, a Grizzly, maybe a sun bear?

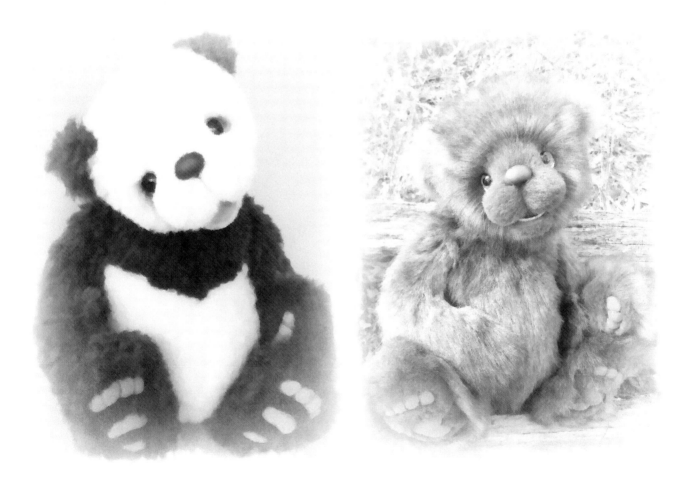

Even when your designs are right and your work is selling, continue to seek feedback. You may choose to stick to your own creative style regardless of comments received or you may wish to adapt your style to your market. You may find a particular bear sells well. You learn it's because your collectors are preferring to buy smaller bears because space is limited. Or you may find the bears with the extra patches under their eyes are highly sought after and always sell within minutes. You have two choices here; you can continue to make bears on the smaller side with the patches under their eyes and sell them quickly or you can continue to make the larger bears you prefer, knowing that they may take longer to find homes.

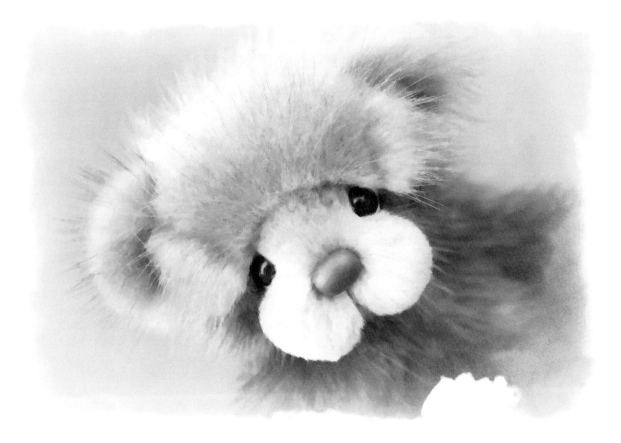

Your Business Plan

You must have a business plan, a vision, and a goal. Always have a plan. My plan for this book, for instance, was to make a beautiful, inspirational guide. I knew my audience would be bear makers, and knew to include the things a bear maker novice or advanced craftsman would like to see included. I also understood that many of my collectors may like to own the book authored by the artist of the bears in their bear collections. This confirmed that the additional hundreds of dollars I invested into creating this book in soft and hardback copy was an investment, not an extravagance. Because I had a clear goal I was focused, and decisions were made much easier. Your business plan may be to create and sell one or two bears a week, or just a few signature bears that demand much time for the extensive techniques thus limiting your number of pieces to just a few every year. Regardless, you will need to keep quality your number one priority. This will be improved consistently with each bear. Having a dream is good, but what's the plan?

I always wanted to be awarded a Toby. However, year after year I did nothing, never entering the competition, feeling it was too hard and I was not good enough. How would I win if I never entered? I asked myself. Would it be that bad if I entered and did not win? Self doubt is a disabling quality. That year, I had a plan—a simple one, Enter a bear into the competition. That year I entered my bear and won an Industry Choice Award. Have dreams, make plans and act on them; it's this action that eventually fulfils your dreams.

The business plan for my club was to create a set of patterns with Step-by-Step guides including many basic to advanced techniques. My patterns sell well on Ebay, Etsy and my website. I receive many emails from bear makers asking me for help with a mink face or the best way to sculpt eyes, etc. As the numbers of emails increased, many stated that they liked my patterns and kits and wished they could attend a workshop. However, they lived too far away. I also learned that many bear makers were collecting my patterns, paying over and over for postage. I thought of how I could offer more to these followers, though adding the guides would certainly increase printing and postage costs. Then it came to me: offer the club electronically. This would allow me to include as many helpful photos as I wished. I would be able to show every step in working with mink with over 150 photos. This offered a much clearer way for me to describe each step, showing which direction to trim the face and the angle to hold the scissors. This is like a workshop, only better, as now this club can be a reference tool. I didn't want people to stop contacting me, but now I receive emails saying, " I love your patterns and kits and I am a club member. I have just made my first but not my last mink bear. It's not perfect but I now know what I am doing and can't wait to make another. I hope to one day be as good as you. Thank you for sharing your skills." These emails inspire me. I still have the opportunity to talk to these bear makers. However now we discuss what we want to do next, what they want to try, what I want to try.... Now when I have someone contact me asking how to trim the face I can use the time invested in my club to offer them a copy of the guide. This time invested for me results in people trying new things in bear making. This is a wonderful reward for me, knowing hundreds of people who have already joined the club are now making bears. I have received emails from people saying they have entered competitions with these patterns and won. This is wonderful knowing I have given people the confidence and skills to do this. My club is to me as valuable as it is to the people who join.

Marketing your style

Marketing your bears is creating a brand for your bears. This is easy for many of us, as we will be drawn to either soft pinks and cursive or handwriting fonts. Or maybe you'll be drawn by bright bold patterns and bold word art. Now all your bears will not be the same colour, but think about colours. Do you tend to favour shabby chic, vintage, or retro? Unless you have a colour you just know will never be out of fashion, allow yourself the opportunity to work with a few shades. This will also make working with standard templates easier later when you are in a position to choose from 10 or 15 colours on a palate and you cannot pick your custom hue. Think about fonts and start by creating a single banner or header that can be used in adverts, on blogs, websites, as links and printed out as stickers. This begins to define your brand. Adverts in printed publications can be costly and may only be large enough to include a single bear and your name. You may wish to create a few banners, one with your name prominent and maybe one including a small photo of your bears.

Marketing usually refers to advertising. Promotion tends to consist of other ways of promoting your work such as having your work mentioned by editors in printed articles and even displaying your work in competitions. There are many forms of promotion. I refer to such activities as the administrative aspects of bear artistry. You may submit artwork and adverts for printed publications such as bear magazines and must meet the deadlines for providing profile information. I like to update my photo albums on sites I am a member of such as The Guild of Master Bearcrafters. This may not seem to be very exciting but think about it in a positive light. Make sure you have a focused approach to such work and set aside time for it. You may think that being offered a free artist profile in a published magazine is great, which it is, but it is not free because it demands your time in order to actually draw the eyes of readers. I find that an hour or so on the weekend, say a Saturday morning, after cleaning the house, before working on my bears is a good time to catch up on such things. Obviously not all this work can be completed once a week. Blog entries are often more regular. What remains the same regardless of the amount of promotional work you do is that fact that the more you display the more people will see your bears. So if you are serious, this will take a large commitment of your time. If you are holding down a full time job or have family commitments, then you have some decisions to make. My advice is that if you become too busy, then admit you're too busy. Don't sit and think about all the things you could do. Create a list, and just do one of them. Tick it off and move on to the next when you can.

Always be multi-tasking. I listen to pod casts while travelling in my car. When I arrive home I jot down the things I plan to take on. Sometimes I will listen to many podcasts and take no action, but it helps keep me focused. The best ideas can come from the simplest things.

When trying to create bears and promote them, I think organisation is key. This can be especially important if you have other commitments like family or full time work. Make sure all your supplies are together so you are not buying things you already have. You don't want to spend your sewing time looking for the 6mm eyes you need. I have eyes, joints, discs, tush tags, spare needles and buttons all in one tray, each in small jars. I can take out the one or two jars I need and then put them back in their place. The little jars are great, as you can tip them up to take out what you want. This also makes re-ordering a breeze since you can see what's getting low.

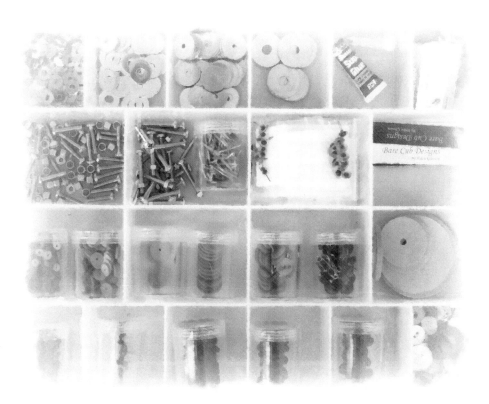

Creative workspace

Think about how much space you have and how much you need. If you are making miniatures you may be able to contain all your tools and supplies in one small box, if you are working with real fur coats you may need a wardrobe (or in my case 3 wardrobes). The truth is you should not need a lot of space but if you have a drawer in your bedroom, you will fill it. If you have a cupboard in a spare room you will fill it. If you have a complete room or attic you will more than likely be able to fill that too. I have a shed that will house an 18-wheeler truck and guess what – it's almost full!

Most importantly, surround yourself with inspiration. This does not need to be expensive art. I created my own by photographing some vintage silk threads, which I have chosen to share with you in this book. These photos hang on my walls and inspire me to create beautiful-quality bears.

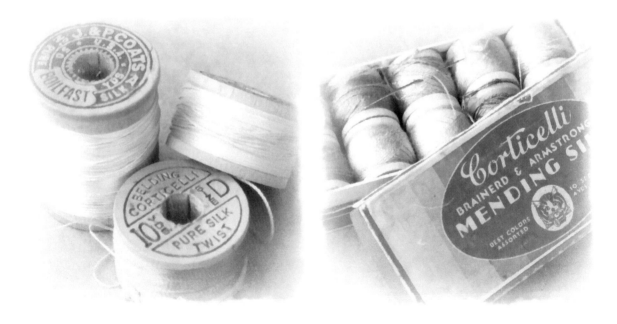

Inspiration comes in many forms

You might be inspired by a favourite ice-cream treat or maybe you'd like to create a gingerbread style bear adorned with cherry gumdrop buttons down her chest and a creamy ric-a-rac bow gathered around her head. Maybe your style is inspired by the vintage cardboard suitcases you have seen at the local market. Oreo and Neapolitan are inspired by my favourite sweet things. Collect your thoughts in a scrapbook and keep this with your bear supplies.

Promoting your Collection

Promotion is not just advertising. All good promotions should encompass many forms and can involve many mediums. Publications are wonderful to be involved with. There are many electronic options now available and, of course, what I refer to as "In the fur" promotion at trade shows.

First, traditional advertising in bear magazines can be costly but consider the audience you are reaching. If you are trying to advertise your bears for adoption, then this could introduce your work to many collectors. If you want to promote your patterns, maybe you would be better advised to advertise in another magazine the publisher also offers such as patchwork or craft magazines that will appeal to a wider range of crafters. Know your audience and your message. Being mentioned in a magazine by the editor is like news. News is more trusted than advertising. If the editor is saying good things about your work, this carries more weight than the artist saying it. Contact editors and let them know about your work. The second medium is electronic and the list is endless. Personal computers are in so many homes now, and smart phones are everywhere, creating a real time medium for social networking. The Internet allows us to share our new work as soon as it's complete, selling within minutes anywhere in the world. If you find this overwhelming there is good news; it's not that hard and you only need to know a few things. If you have access to a computer this should not cost very much at all. Websites and blogs have become easy to create, even if you are a novice with computers. Sharing on social networks has become as popular as traditional communication methods. This allows you to connect with collectors on a regular basis. I will give you an insight into each of these. All of this being said, the sooner you master photography, the better. A good photo can make all the difference.

Attending Shows

Attending shows is a wonderful, enjoyable experience. While the most traditional method for new artists to sell, I must point out it may not be the most economical way to sell your bears. The Internet makes the costs next to nil. Once you work out the cost of a show, it may put you off. The flights can be expensive, especially if you are flying internationally. You may need to stay in a hotel and rent a car. However this can be a wonderful time and can double as a holiday.

You will have the opportunity to meet your collectors face to face, along with other artists who, speaking from my experience, are the most wonderful people I have met. I recall at a Sydney show, meeting an artist named Lorraine, whom I had never met, but always admired. I could not wait to see her and her bears. I had seen photos of her bears and was so excited I would see them and have the opportunity to adopt. The night before the show, I was explaining this to Lucy, my very good friend, who is always there for me when it comes to positive or negative criticism about any and all aspects of my bear making. I was telling Lucy about this wonderful artist's work and how amazing she was. I grabbed my I-phone and showed her a bear. I was doing my best to explain, but doing it no justice. Well, the next morning we were at the showroom early setting up, when a lady came up behind us and I heard a sweet voice. "Oh, you must be Helen Gleeson," she said, looking at my bears. I turned to see a smiling face and she said, "Hello, I'm Loraine."

And just think, I had spent all night wondering what I would say to her. We talked and talked throughout the show. She is as beautiful as her bears. This is a great reason to attend a show, even if you can sell your bears other ways. It is interesting to see people identify strangers by the collection of bears that are displayed before them.

Shows are not only going to cost you time and money but you need to, in my words, "hoard bears" leading up to a show. After all, you will need a collection of bears to sell. Displaying your bears can be a great way to express yourself and your style. Keep in mind size and weight of the objects you are going to take, as this all needs to fit in your luggage, unless you are as lucky as me and have a friend like Lucy who is happy to attend shows with you, offering up space in her suitcase too.

There are endless possibilities and you can take along the objects that inspire your bear making. I have several displays. Since my bears are created from vintage coats, I like to display my work in vintage sewing boxes full of vintage silk threads and vintage buttons and needles, all flowing out of drawers and vintage cigar boxes. At another show, I had created a collection of mink pandas, all with panda patches under their eyes. For this I used sheets of soft green moss I purchased from a florist. I found a hollowed out piece of wood in the garden—finding logs is easy when you live on a few acres of Australian bushland. However, if you think about it, beautiful light logs are available from pet stores for snakes, fish, and crab tanks. I also like to add a few orchid twigs also found at the local florist shop. This would work well if you create fairy bears with wings. You could create an enchanted garden by adding toadstools made from cream clay. Old suitcases are an all time favourite display and will work well with almost any style of bear. You can add a few wooden toys or just fill with vintage handkerchiefs collected at second hand stores. I often photograph my tiny 2.5" Choc Chip bears in ceramic cupcake wrappers and so I have collected many of these little ramekins and ceramic milkshake glasses. While I cannot take all these on a flight, because of their weight, I can take along a few, and a demountable cake stand to place in the back of the display, offering the inspiration, without all the weight of taking the whole display along.

Your Show Checklist

Here are a few things to think about for attending shows.

Packaging

You will need to have boxes or bags to suit your bears. As my bears usually range from 2 to 8 inches, they all fit perfectly into mug boxes I purchase. As I've said, I cover and embellish the lids. I will often need a box for the 8-inch but can place 2 smaller bears in one box. I will pack all my bears just before the show and, if flying to the show, I will take these boxes in my hand luggage. I can't bear to think they could be lost or simply sent to the wrong place, leaving me without any bears to show.

Price tags

You will need to price your work. I print out little table setting place cards that have the name and price on one side and I can flip them around to show the "Adopted" sign on the other. If you have bears for display only, that are not available or adopted, it is a good idea to mark these bears as "Adopted." If you have a 'not for sale' sign you will spend all day explaining why, or worse, be tempted by someone who starts to pressure you to sell the bear you wanted to keep.

Change

You will need change in coins. Now this might seem obvious, but I remember my first show. I guess I just didn't think about actually selling a bear. I didn't even realise I had no change until I took the money and realised I could not break the note! You can also accept credit card payments by contacting your bank and asking about a merchant agreement. This can cost as little as $10 a month and a small percentage of the payment. If you choose to accept credit card payments via the manual process you will need a mobile phone to call through the sales and obtain an authorisation number before releasing your goods.

Business cards & Order book

Take along business cards and printed materials to promote your name and website. If you are accepting orders, take along your order book, making sure you capture all the required details.

Display

Along with your display items, you will need to take along other items such as signs stating that you accept orders through visa or by lay a way. If tablecloths are not supplied, you will need to bring one with you. Crushed velvet is available in many colours and will not need ironing after being squeezed into a suitcase. If your art has been featured in magazines, take these publications along, and even a photo album of past work. Again if you accept orders, this may assist when talking with collectors about what they would like to order.

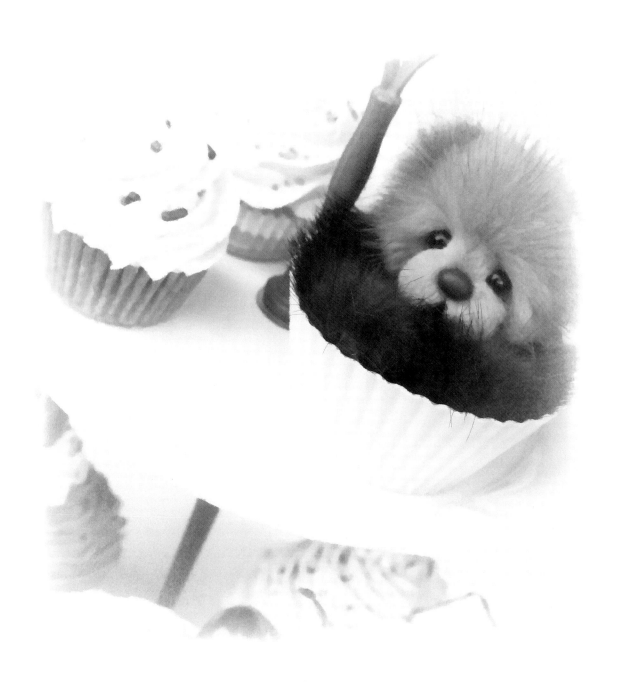

Photography

Digital SLR's have become more affordable for individuals, and are no longer restricted to the professionals. Now you can use the auto options, but that does not seem too creative, now does it? Of course not. Many creative styles can be obtained by knowing your camera and its settings. You can learn a lot about your camera online from blogs and the manufacturers' websites. Try many different backdrops. These can consist of a large sheet of card in many colours; or if you require a larger cover, then a few meters of fabric may be a better option. Stay away from patterns and shiny fabrics. Even a strong fabric weave can jump out of a photo, detracting from your bear. Regarding props, try to keep the subject clean and simple. For example you may include a few blocks with the bear with its name or initial on it. Think about using the focus length to blur the background, keeping your bear in focus as the centre of attention. Lighting is important, as with any photography; but before you go out spending thousands of dollars on a light for your studio think about the best light we have, the sun. Take your photos just after dawn or just before dusk. This is a great time as light and shadows should not be too harsh. The best part about digital photos is we can now take hundreds of photos, picking the best of the best for publications.

Technology

Do not dismiss what technology can do for your business. Embrace the Internet and the benefits it can offer direct and indirectly. The Internet is more than an advertising channel; it is a two-way communication path between artist and collector. You can start out with a blog with basic template and then link to a website displaying galleries or current and past works. This is then expandable, as you add links to other sites and stores selling your art. When required, simply upgrade to E-commerce, offering collectors the option to buy your bears directly from your site, making instant payments to you.

Websites

Take advantage of the many web design companies offering easy-to-use templates. Remember, your website can be very simple yet effective. The key is to promote your collection. Choose the right colours for your look and make sure, above all, it's easy for collectors to navigate. Offer side buttons for each page containing headings. Ease of navigation is important, so collectors can enjoy spending time looking at your bears, without wasting time skipping from gallery to gallery. Include the following pages:

"Home page"

A welcoming comment about who you are and a photo of your work should show collectors who you are and make them interested to see more.

"About the Artist"

An introduction about you to your collectors is in order, including who you are and where you live. Add a little history about your bears and how you started out. Include the time you spend on your bears, whether you make them full time or just make them on weekends due to your full time career. Include the style of your bear and why, commenting about what makes your bears special.

"Awards"

Proudly list awards won and other recognition, such as profiles in publications. People who like your work may wish to contact the publication displaying your work and order a back issue. Awards convince your collectors that you create bears that are well made and liked.

Mailing list

Start a mailing list. This helps with promotion. This can be very simple, you can use a web based mailing list company (just Google mailing list). After you supply the required information, they will give you a widget or badge to put on your website. This badge will allow people to join your mailing list and many also offer simple newsletter templates that help you market yourself in yet another way. My website has a Bravenet badge – I also have a button on my blog directing people to this web page. It's also a good idea to use the extra space to tell your collectors about order info like postage, payments and deposit information. A mailing list can be used to notify followers of new bears, shows, workshops, and other events with which you will be involved.

"Gallery of work"

Start with just one gallery and, as the number of bears grows, create multiple galleries for collections of work. Maybe, like myself, you prefer to make traditional bears but are known for working with real fur and need to separate the two. Or you may wish to create many large bears but have a miniature signature style which is highly sought after. Separating these allows people to look at both but easily view the style they wish to collect. Name your bears so when people contact you by email they are not left to say they like the one second from the left on the bottom row or the second one on the third page. Include useful information such as size, fur used, type of stuffing, eyes, and other important information relevant to your bears.

- Home
- Artist & Awards
- Available cubs
- Custom Orders
- Mink Gallery
- Traditional Gallery
- Patterns & Kits
- Bare Designs Club
- Contact & Mailing list
- Links
- Shows & Events
- Book Release
- ~~~~~BLOG~~~~~

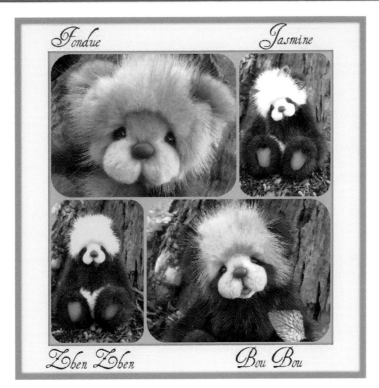

Fondue *Jasmine*

Zhen Zhen *Bou Bou*

"Contact & Ordering Info"

An important page is the one answering some of the frequently asked questions. This will free up your time spent replying to emails and also allows your collectors to know how to contact you if their question is still unanswered. Also include the terms by which bears can be adopted and the payment methods you accept. You can upgrade your website to being an E-commerce site by activating a PayPal account and using their supplied buttons to take payments directly from your website. You are notified by email when you have sold something from your website. You can also select the number of products when creating the button. When selling a bear, obviously you only want one person to buy the bear. When listing kits you can have inventory set to ten, so that when one sells there is no need to relist. You can also have a 'low inventory' reminder sent to you via email when you, say, have only two left, reminding you to make some more.

"Available for Adoption"

This page should be your sales room. When a new bear is ready to find a home, listing him here will allow collectors to find your work. You can create a blog post about the new bear, offering a link to your available page for additional information and even an option to buy. Once your bear has found a home, remember to update the page with a sold or adopted note, saying this bear has found a home and another bear will be listed soon. If you accept orders you can mention this on the available page.

Bare Cub Designs

- Home
- Artist & Awards
- Available cubs
- Custom Orders
- Mink Gallery
- Traditional Gallery
- Patterns & Kits
- Bare Designs Club
- Contact & Mailing list
- Links
- Shows & Events
- Book Release
- ~~~~~BLOG~~~~~

~~Free "clay nose workshop" below - scroll down~~

Bare Designs Club

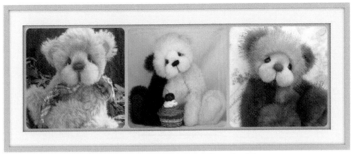

Join the Bare Designs Club and you will receive 12 patterns

exclusive to Bare Design Club Members, not available anywhere else

you will access 12 patterns straight away when you join

This new collection will include tips and tricks, step by step guides with lots of photos,

tools of the trade we love and loads of ideas, options and techniques.

"Patterns & Kits"

If you offer patterns and kits, along with Ebay and Etsy, your website is another economical way to offer those you have available. When you register with PayPal you have access to create instant payment buttons to display on your website. This means no credit card information is given and many people feel comfortable making payments with PayPal. You can also list a pattern and kit on the same button: "If you like my Tim Tam bear you can buy the pattern for $15 or the full kit is listed in the drop down button for $100." This reduces the number of items you need to display. One-of-a-kind bears can also be sold. You just create the button, telling PayPal to only offer one before going out of stock. When your product or bear sells, you receive an email advising you of the purchase.

"Links"

Offering links is a great reason for people to stop by your website. Viewers will know this list is great for browsing and will stop by regularly to use it. Make sure you offer links to where your work is available. Include resources such as suppliers, magazines, etc.

"Blog"

An external link will direct viewers to an external page elsewhere on the World Wide Web. By clicking on the "Blog" button displaying visitors to my website are directed to my blog. Traffic can, of course, be directed from my blog to my website.

Blog

Your blog should be a destination—somewhere people want to visit. Typepad and Google's "Blogger" are a great way to keep fresh new communication on a regular basis with people who admire your work. The best part is its interactive capabilities, allowing followers to comment. You can learn a lot by these comments. Don't feel you can only blog about a new bear that's available. You might want to share a new ribbon supplier you have stumbled across, or a new fabric and yarn store that now has a web presence, offering a link to the site. Or maybe you have bought a new book like this one and want to share it with others. In the case of my book, please refer followers to www.barecubdesigns.com or amazon.com to find this book – thanks!!!

Create custom buttons

You needn't buy pretty buttons to display on your blog. Buttons can be easily made by taking photos and adding text, using a program as simple as Paint. Blogger allows you to "add an external link" to a picture, so when someone clicks on the picture stating website, for example they are directed to your website, or perhaps they are taken straight into your eBay store.

This not only makes it easy for people to navigate their way around, it makes your blog beautiful and inspirational so people want to come back regularly to see what you have been up to.

E-Commerce sites – eBay, Etsy & Bear Pile

Although you offer buyers the option to buy straight off your website or prefer your collectors to email you for an adoption, eBay or Etsy represent another great way of promoting your work. You must think about how you want to sell your work. Do you have a particular price you need. You can set as a buy-it-now price or include a reserve price allowing for bidding over a particular time period. When you have more collectors than bears, this is something you need to think carefully about. "First in best dressed" is good but are you excluding collectors in another time zone. eBay and Etsy have rules and you need to see if they suit the way you wish to sell your work. Etsy offers an environment where artists sell their art and handmade craft wares. This brings your work to a wide audience of people who appreciate art in many forms. Bear Pile is a special site dedicated to bear art. Of course you should have your blog and website offering your available cubs.

Social media – Facebook & Networking sites

These sites are more than just a way to promote your bears. They are wonderful places where artists and collectors come together to share thoughts and ideas. Read the articles and leave a comment. Take part; don't just be a spectator. Comment on other blogs and these artists will comment on yours. Take on comments about your work, and, most of all, be inspired. Of course it's great to talk with loved ones about your bears, but these sites offer networking opportunities with future mentors that are like-minded. I offer links on my website to these places where people can find and follow me. This is a great way to connect with people and form friendships.

Selling your work

As soon as you start to offer your art for sale, keep good accounting, bookkeeping records. Contact your local small business centre and tax office for advice and understand your responsibilities. You may be able to work under hobbyist guidelines, but keeping records will let you know when to start acting like a small business. Think big!

Pricing your work

To calculate your prices you need to consider the materials used and what they have cost you to purchase, including any ribbons or accessories. Your time is also worth money and you must decide what you choose to charge. Also if your bears have a special skill then this should be incorporated. I recall my first real bear sale. I listed a bear on eBay. Not sure what to charge, I created the listing with a low starting price, fearful that no one would bid on my little bear. He was cute and I thought to myself "Be positive. If I like him, surely someone else will. I see little miniature bears sell for hundreds. Why shouldn't he?" So I stopped the doubt and added a buy-it-now price in case a collector came along, met the creature and wanted to adopt him no matter what. I added the, at the time what I thought was a pretty good price of just under $300. I completed my listing and pressed submit. Instantly the doubt crept back in. I went back into the lounge where Ray was. He asked, "What could be so important on the computer on your birthday?" I explained I just listed a bear for sale on eBay. Ray walked into our home office asking to see the listing. I bought up my "Active Listings" to find it was gone. In bold print it said, You have "0" active listings. We both looked and then I said, "What happened? I listed it, I checked it. Could it have sold?"

"No way!" I thought. Oh my goodness, I quickly checked to see "Sold Listings." "He sold!!!!!" I screamed out to Ray who had, by now, had left the room. Buy-it-now had worked. I will never forget that birthday.

Tush Tags, Swing Tags and Packaging

Think about the size of your bear, as this will affect the tags you put on it. If your bears range in size, think about the smallest you intend to create. Or if you plan to make 2-inch and 22-inch then keep this in mind, as you may choose to have two options. These do not need to be elaborate or cost much.

Tush tags can be as simple as a slice of suede with your name on it sewn into the seam of the tush! Alternatively if you would like a very professional look, printed ribbon is a good option. It may be expensive initially but these printers keep the plates on file and your re-ordering is more cost effective. Also a roll may include thousands of names as they can be printed every 40mm or so. I like to have a dark and a light but perhaps you need a neutral and a colour. I purchase mine from Australian Printed Ribbon.

Swing tags can be printed at home on your personal printer, or professionally printed. Many artists use moo.com as they offer 100 mini tags, which can have up to 100 different photos for less than $20. These can have your business on the front and a simple message on the back such as mine "May your new cub bring you many smiles." Add an eyelet and string.

Packaging needs to be over the top. You may need to use a standard box due to size of your bear. You will need to think about how it is going to be protected----maybe by bubble wrap. If you are working with real fur you do not want to place plastics on the fur. I choose to use vintage pattern tissue paper collected and recycled just like the fur garments. I purchase inexpensive mug boxes for a few dollars each and cover the lids with pages from novels and old music sheets collected at local second hand stores. I then add a few simple embellishments such as stickers of my bears made at moo.com or a hand stamped ribbon, and a few flowers.

Accepting Orders

You may prefer to imagine one bear and then make it, not being deterred. Or you may like to have three or four on the go. Maybe you'd like to have one miniature and one standard size at all times. I like to have many choices. I keep my waiting list and orders in plain cardboard trays. They are not exciting or colourful but they are convenient and organised. The benefit of this is it keeps me honest. I can't pretend I have no work to do. It also means that after a long day at the office if I do not feel like inserting a head gusset I can simply stuff some limbs, or sew up some ears. On the other hand if I have a creative energy burst I can start inserting eyes and sculpting a face. Here is one of the trays I use to store many of the orders I am working on. It's made of simple paper mache boxes inside one large one. I have 3 or 4 of these trays. This ensures that when I have agreed to create a bear in a particular fur I cut it up, place a nametag in with the fur and I will not be caught running out of the right colour.

When you get all this right, your bears will sell, and you will need to keep making them. This is where that passion is tested. Will you only sell bears that you make or will you accept orders? There is no right or wrong here. You may feel that you want to simply create the bears in your head and don't mind if others love them. They may fly off the shelf or they sit there til the right collector comes along. If you have a collector say they want a particular size and colour combination, and you're happy to create it, then working on a bear that already has a home may appeal to you. Some artists will move between both options; maybe they creatively have things they want to try or competitions and shows for which they need to prepare. Or they have taken on so much work they need to stop taking on more orders until they catch up again. I don't mind deadlines, but what about when my waiting list is longer than I can calculate? Like when I go from thinking, OK, I can have these all completed by March, then perhaps May—then thinking, Gee, how long is this going to take? Factoring in shows, I won't get it all done this year!

I can just imagine many of you are thinking, how can you get that busy? Well, first your bears need to be what people are looking for. Don't be put off if, at first, they do not sell like hot cakes. Your bears need to be promoted, and people need to feel comfortable with your style. Sometimes people will see your bears for a long time before they actually commit to buying one.

I suggest one reason for this: your work needs to build credibility. Unless people see your work in the fur, they may not at first be confident in your work. Many collectors have spent good money to find the seams in their newly acquired piece are not sewn well and they are disappointed. To improve this you can enter competitions. The people's choice competitions are good as this is a great way to have your bears seen, but do not underestimate the power of a formal competition offered at shows. You may feel you know what needs improving and you don't want your work to be criticised. But I remember thinking my ladder stitches could be improved, and I focused all my attention on these. Meanwhile I was neglecting the amount of stuffing in the ankles of my bears. I entered a well judged competition and to my surprise read "Wonderful ladder stitches" but " watch the even stuffing of the legs; ankles seem to be soft" So the next competition you improve, and there is nothing like winning the next one you enter. These results are sometimes picked up by the bear magazines, and collectors will now trust your workmanship. You can have a list on your website of awards you have won and display your medals. Golden Teddy and the Toby Awards are Industry choice nominations and people's choice but they are very prestigious awards with which to be honoured so submit your work to these types of international competitions also.

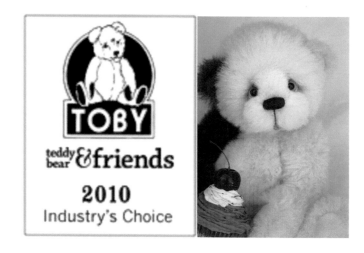

In the Press

Being published in magazines is as good as it gets for an artist. Now I am not talking about adverts, although advertising should be part of your marketing plan. I'm talking about having your bear award announced or having your work profiled. Profiles are where people learn about you and "put a name to the face." This helps make you memorable; then when someone mentions your name others will say, "Oh yes, I know how she started out," and the conversation is about you. Now there is no secret to getting on the cover of a magazine. In most cases the editor will contact you, as Teddy Bear Times UK did in my case. I received a lovely letter from the editor saying, "We have received requests from some of our readers asking about your bears. One letter in particular was so positive about your work we just had to see for ourselves. We agree." The letter went on to say they would be happy to offer me a place in their magazine to profile my work. This was so exciting for me. You can imagine my surprise when I was asked to re-take one of my photos, they wanted the bear re-photographed exactly the same way, just on a solid white background. This seems like a strange request, so I suggested I use a soft blue background instead. Their clarified response came back: "White is better, as we print text like article headings and the magazine name on top of the image, for the cover." A Cover Shot! Well, I can tell you, I was straight off to the art supply store for a sheet of pure white card and the camera was very busy that afternoon. What an honour for China to be on the cover of an international magazine. I have a special place in my heart (and home) now for China and Tiger Lilly, my little stars.

A good way to be seen in magazines is to offer patterns or "projects" to the editors, allowing them to print them for their readers. Many artists like to be paid for this – and of course that would be nice, but think of this as advertising, which costs money. A small advert, on one page, can cost several hundred dollars, and you will have your pattern spread over 4 or 5 full pages. Of course this is not free as it costs you time which is of value, but so is this promotion of your work.

I offer a clay nose workshop on my website promoting my Bare Designs Club. This is a club offering 12 patterns, including step by step guides on sculpting, inserting eyes using the button method, slit method for miniatures, aging a bear, creating beautiful feet pads and many more. I have a button on my blog offering a free nose workshop, this button directs people to my club page which lets them know about joining my club. Many people who like the style of the step by step display showing how to make a clay nose, then feel the club will be of value to them and they'll sign up right there and then. Offering your expert advice is a good form of promotion.

The final note

Take advantage of networking. Formal and non-formal mentors are important and can be honest with you about your work and also a great resource for inspiration. They can also challenge you to try new things. Join networking groups. Think of yourself as an independent artist and entrepreneur. Be creative and inspired to create beautiful bears, while retaining a business viewpoint.

A wonderful world awaits you and your bears. Work constantly to improve. As your bears become more and more in demand, streamline your business process, remain organised and forward thinking. I hope you are inspired by this guide and all that is around you. Look at fur in a fresh light everyday as you realize what can be created from it. Enjoy it, Love it, Live it and of course remain balanced between your passion and your life. Have dreams and make them your reality.

As Always

Happy Stitching!

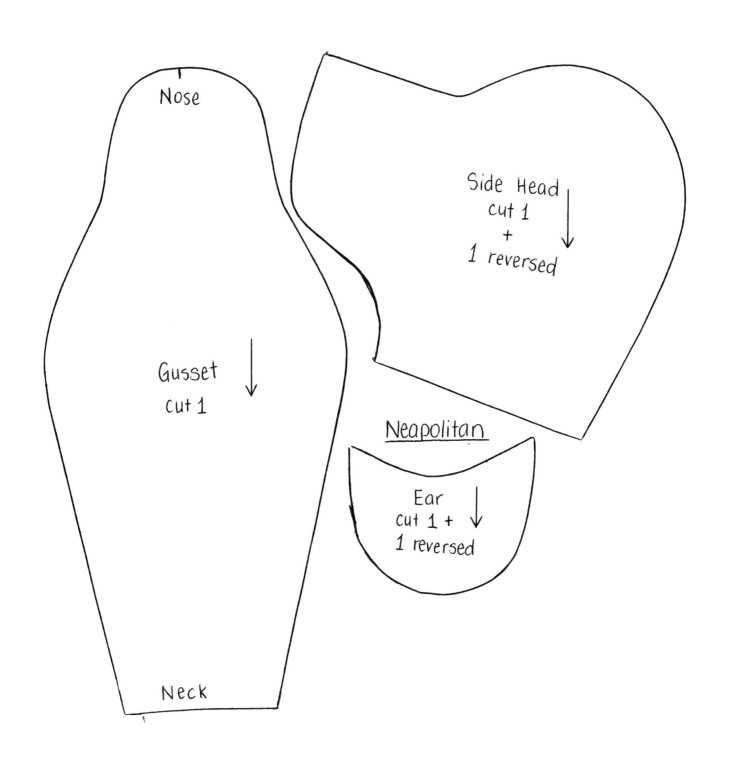

Nose

Gusset
cut 1

Neck

Side Head
cut 1
+
1 reversed

Neapolitan

Ear
cut 1 +
1 reversed

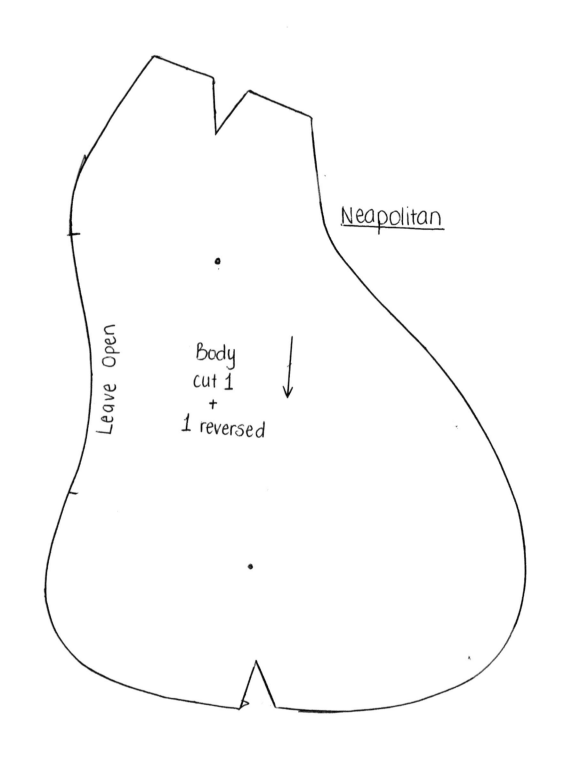

Neapolitan

Leave Open

Body
cut 1
+
1 reversed

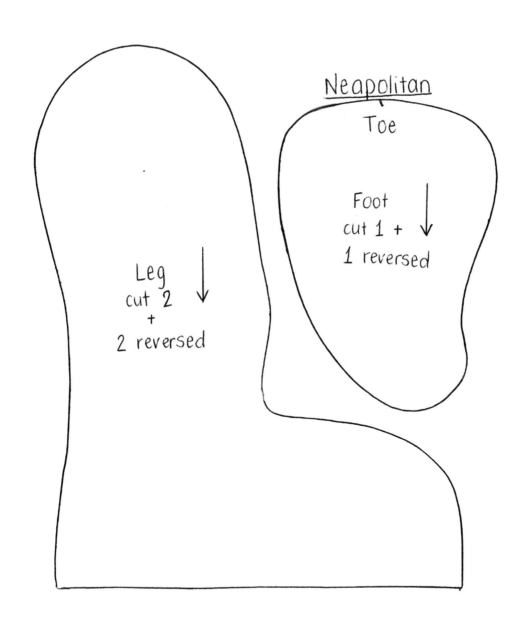

Neapolitan

Toe

Foot
cut 1 +
1 reversed

Leg
cut 2
+
2 reversed

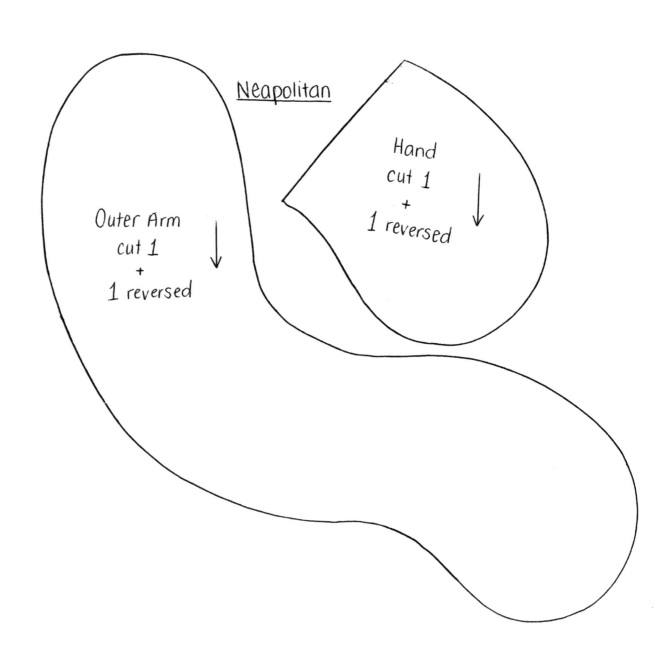

Neapolitan

Outer Arm
cut 1
+
1 reversed

Hand
cut 1
+
1 reversed

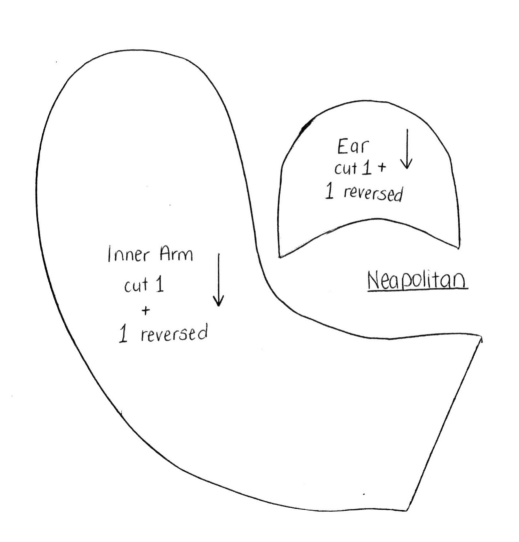

Inner Arm
cut 1
+
1 reversed

Ear
cut 1 +
1 reversed

Neapolitan

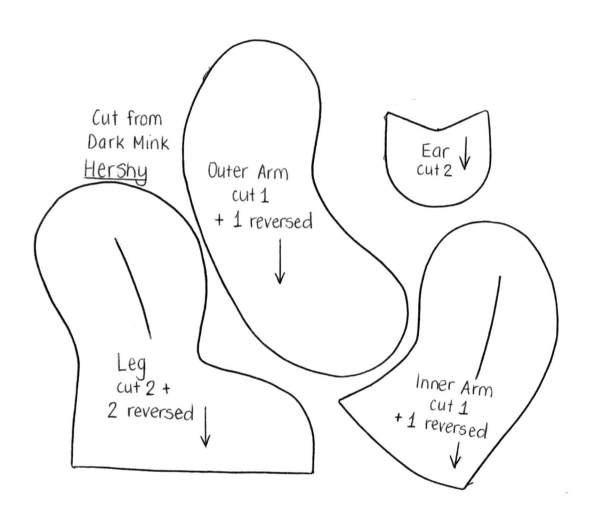

Cut from
Dark Mink
<u>Hershy</u>

Outer Arm
cut 1
+ 1 reversed

Ear
cut 2

Leg
cut 2 +
2 reversed

Inner Arm
cut 1
+ 1 reversed

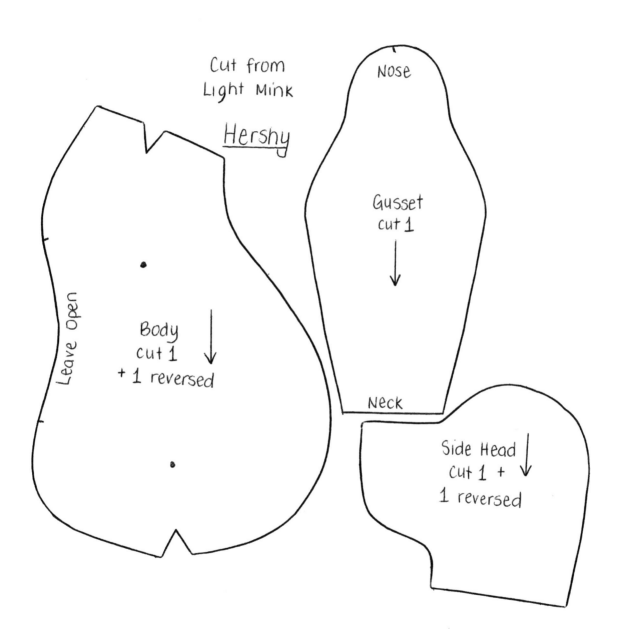

Cut from
Light Mink

<u>Hershy</u>

Nose

Gusset
cut <u>1</u>

Leave Open

Body
cut 1
+ 1 reversed

Neck

Side Head
cut 1 +
1 reversed

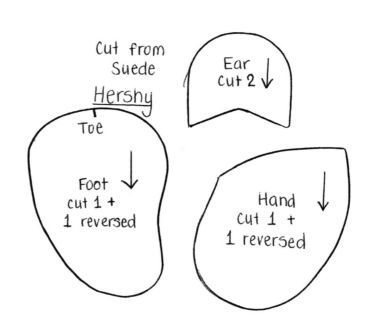

Cut from
Suede

Hershy

Toe

Foot ↓
cut 1 +
1 reversed

Ear
cut 2 ↓

Hand
Cut 1 +
1 reversed

To see more of my cubs, follow my creations or
join the Bare Designs Club, please visit my website
www.barecubdesigns.com

Please feel free to drop me a line to ask any questions or
just say "Hi" and keep in touch with me my email address is
helen@barecubdesigns.com

CPSIA information can be obtained
at www.ICGtesting.com
Printed in the USA
LVIC06n2120281114
416040LV00009B/81